This Book Belongs to:

A flow BOOK

A BOOK THAT TAKES ITS TIME

An Unhurried Adventure in Creative Mindfulness

Irene Smit
Astrid van der Hulst
and the editors of Flow Magazine

WORKMAN PUBLISHING • NEW YORK

Library of Congress Cataloging-in-Publication Data is available.

ISBN: 978-0-7611-9377-7

Design by Lisa Hollander and Studio 100%
Cover Illustration © Clarice Gifford
Typesetting by Barbara Peragine and Elissa Santos
Additional credits may be found on page 217

Workman books are available at special discounts when purchased in
bulk for premiums and sales promotions as well as for fund-raising or
educational use. Special editions or book excerpts can also be created
to specification. For details, contact the Special Sales Director at the
address below, or send an email to specialmarkets@workman.com.

Workman Publishing Co., Inc.
225 Varick Street
New York, NY 10014-4381
workman.com

flowmagazine.com

Printed in China
First printing August 2017

10 9 8 7 6 5 4 3

Contents

The Time Is
Now

Time is the new luxury these days. At least that's how it can feel sometimes. What happened to the child you once were, who could contentedly watch a ladybug for hours on end or while away entire afternoons plucking flowers and concocting perfumes from their petals? What happened to the long holidays, those idle weeks spent doing nothing, just hanging around with friends—with no sense of the passing hours?

Nowadays, everyone's time is so precious that we all want to plan it down to the second. We think we can accomplish more if we plan our time well: We can be good parents, good employees, good friends, and good partners while still managing to read books, see movies, enjoy the great outdoors, work out at the gym every now and then, and, and, *hmmm.* Somehow we believe our lives are more worthwhile when we do as much as possible.

But is that really the case? Is there enough time to truly enjoy all the things we are doing? This notion nags at us. Because with all this planned time—with all our to-do lists, schedules, and plans—there is so little time left to experience life as it is. So little time left for coincidences, surprises, spontaneous get-togethers, and idleness.

Everyone knows these things are essential: It's during moments like these—when we have a bit of spare time, when there is nothing going on, when all is calm—that little doors appear. These doors open to reveal new thoughts and new notions; paths to creativity; paths that lead to great plans, funny ideas, and happy thoughts.

About eight years ago, we both came to the conclusion that we were really missing this sense of restfulness. We were fed up with living lives that were too busy, and were suffocating under the weight of plans. And—if we're being honest here—we also seemed to be accumulating problems. We ruminated, worried, and felt ceaselessly tired and stressed out. It got to the point where we felt we were living in a snow globe, constantly bombarded with cold calculations and thoughts.

We had vaguely heard about the benefits of mindfulness, or the act of focusing on the here and now with attention and acceptance. So we completed an eight-week mindfulness-based stress reduction (MBSR) course. We learned that you don't always have to be doing something, that it is worthwhile to simply acknowledge the activity within the snow globe and appreciate the beauty of the snowflakes. That we can quiet our minds. If we just do nothing. If we just remain in the moment. If we just observe.

And that's how mindfulness came into our lives. A lot has changed since we took that first course in 2008. Mindfulness practice is growing rapidly worldwide: There are a growing number of

MBSR trainers around the globe, and an increase in research regarding its benefits. Mindfulness is exactly what people need in this day and age. Attention—one of the cornerstones of mindfulness—has never been as scarce as it is now. According to a variety of specialists, many of us are dealing with an overloaded attention system. The moments we have for recharging are becoming fewer and farther between, leaving us in a perpetual state of feeling like we have to multitask to catch up, even though research shows that multitasking is exhausting for the brain and doesn't save time in the long run.

We need more stillness, more downtime, more mindfulness. And that's what this book will bring you. In fact, we invented something entirely new to do just that. This book's form is an extension of its message. In each chapter, we aim to inspire you to make time. Time to breathe, time to learn, time to create, time to reflect, time to let go, and time to be kind. Each page encourages you to linger and truly engage with each topic. Hands-on activities like crafts, prompts, and journals take you on detours and result in lovely keepsakes.

Life is so much better when you enjoy living in the now, when you focus more on the beautiful moments, and when you don't expect so much of yourself all the time. We hope that our book will help you worry less, feel more at peace, and change your perspective. We encourage you to keep flipping through the pages to discover the satisfaction we have found through mindfulness. Just don't forget to take your time.

Irene & Astrid

TIME TO BREATHE

Life can get crazy. Between plans, dreams, hobbies, children, friends, and more, the things that give us that buzz in life can also drain us. And when they do, we realize what we need: more time to breathe. Or, more concretely, *away time*. Time to just step through a curtain every now and again and arrive on the other side in a forest or a little house by a lake, where nothing at all needs doing. Where we can read books without any interruptions, look for pebbles on the beach, or watch a campfire slowly die down. And while we're there, beyond the curtain, there are no appointment alerts or beeping messages— because we are, officially, *away*.

Our tendencies toward overscheduling allow for very little away time, but that time when you are unreachable is necessary in order to recharge, reboot, and ultimately be able to move forward and be meaningfully productive again— not to mention make it possible to keep enjoying everything else (like working, attending parties and classes, putting meals on the table, paying bills, reading the news, taking care of our kids, and other Really Important Stuff). Away time is time when your mind can be quiet for a bit. And it's in moments like these that new things have room to bubble up; little or big solutions for the little or big problems in our lives.

Look, a Beautiful Moment

by Irene Ras

It's so easy to fall into the "can't do it, too busy, no time" mode just going about our day. But when we do, our lives can become too structured and we suffer from a lack of spontaneity. We really *can* stop to smell the roses.

Last spring, in one of the busiest squares in Amsterdam, a giant bird's nest was perched on the top of a bus shelter. It was big enough for two people to climb into it, with a soft, furry cushion inside and a lovely view of the clear blue sky. It was created and installed by the Netherlands Forestry Commission and street furniture maker JCDecaux to remind city dwellers to stop and appreciate the wonders of nature.

Below the nest stood two park rangers, inviting passersby to climb up a rustic wooden ladder into the nest. It was a gorgeous sunny day, and anyone who felt like relaxing and enjoying the moment was welcome to sit or lie down in the big nest, they explained. "It's an energy boost," said one ranger named Erik. He hoped that as many people as possible would climb up there, chill out, and recharge their batteries.

Karin, an onlooker, tweeted, "Cool promotion by

Write down as many wonderful moments as you can. No long narrative; just a few sentences.

the Department of Forestry. A mega-size bird's nest." The department tweeted back, with the question "Did you climb in?" Karin's response, "Afraid not. Had to rush off to an appointment."

I totally get Karin. Sometimes I'm irritated during rush hour if someone is just asking me for directions, so what would I make of spontaneously taking time to lie down in a bird's nest? It isn't that a (small) bird's nest in my garden doesn't give me pleasure. It's just that during the day, I'm often too busy with what still needs to get done *right now*, and before you know it, the day is over.

This afternoon, next week, next year, or the next 40 years—I'm willing to put energy into the future. I also have the tendency to mull over certain moments from my past—yesterday, last week, last year, or even much farther in the past. But the now—the present moment—is a lot harder for me.

At home, I've gotten into slow food (I sometimes bake bread); I'm into slow reading (I read before going to sleep); and sometimes I don't empty my mailbox during the weekend. In these moments, I can see that it doesn't help to focus on the past or the future; the "now" is most important.

I am not the only one who has started to explore this. "Slow" culture is being celebrated everywhere these days. Slow Medicine, Slow Management . . . recently I was invited to a Slow Barbecue (how slow can you go?). And even for those of us who are conscious of the value of the "now," it often eludes us. We try really hard to be in the now, but we often have a tricky time getting there. *Nice bird's nest. Gotta run.*

FEET IN THE SAND

"What if you could work a little less?" my friend Marie hesitantly asked. It was more like a rhetorical question. "As if I could" was my first thought. "You have so little time to do the fun things," she said very carefully. Meeting a friend; going to the beach. She didn't mean that we should be busy trying to have fun all the time, but letting go of yesterday and tomorrow for a while can feel good sometimes.

Marie was very ill recently. It was a close call, but she is still here. While she was sick, I didn't focus as much on all the tomorrows. My busy schedule didn't matter as much. Everything could wait. I was in the present with her. One day, she and I were at the beach, with our feet in the sand. She must have said "What a fantastic day" at least ten times that day. "This is happiness!" When I think of that moment with her, I remember that being happy doesn't have to be complicated. And now? Now Marie is healthy and I am living in tomorrow again.

I admit she's right. Maybe I could work a little less. I haven't enjoyed many beautiful moments lately. There's always something I need to do instead.

I shouldn't have to wait for my friend to get sick for us to share wonderful moments together.

Dutch psychologist and life coach Marlies Terstegge, who in the last few years has been specializing in positive psychology, says that allowing ourselves to enjoy the beautiful, spontaneous moments of our lives is the real key to happiness. "Cherishing wonderful moments starts with living them," she writes in her book *Geef flow aan je leven* ("Give Flow to Your Life"). "When I ask clients what makes them happy, they often give general answers like 'taking a vacation' or 'going to the movies,'" she says. "But if I ask them what kind of vacation they mean, then they have to think about that. It has to connect with what you value personally. And it's these values that we need to seek out."

Marie's suggestion—work less, enjoy more—kept popping up at unexpected moments. One particularly beautiful day, Marie went off to the beach without me. I couldn't make it, I told her, because I had Important Things to Do before I had to go to an Important Meeting. But what was so important, if I can't even remember what it was?

"Some people let themselves be the victims of their circumstances," Terstegge explains. The glass is always half empty for them. She speaks of the mindfulness teacher Byron Katie, who became very depressed at the age of 30 and stayed that way for years. Finally, she got out of it by asking herself, "Is this really that bad?" and, when she had negative thoughts about things, "Is this true?" We can learn to look at the situation we're in. "Think about how important this situation really is and what you need to let go of to enjoy it," says Terstegge. Often, the glass isn't even half empty; it's actually full. And by looking at it in a different way we can create a wonderful moment.

AN IMPORTANT AFTERNOON

But what is the best way to cherish those beautiful moments? "Just write down as many wonderful moments as you can," suggests Terstegge. "No long narrative; just a few sentences. Think about what made the moment so lovely and maybe add a photo if you like. You can collect moments in an album or a box, and go back to them again sometimes. This reminds us what really makes us happy."

Were things so bad that I couldn't stop and enjoy part of the afternoon? Did I really have no time? I shouldn't have to wait for my friend to get sick for us to share wonderful moments together.

Later that day, I changed my mind and I went to join Marie at the beach. We put our feet in the sand together again. "It's so great you made it!" Marie said several times. I ended up being only five minutes late for my Important Meeting and I took care of the Important Things in the evening. More important, I don't think I'll forget that very special afternoon. Later, I wrote down: "Great day. To think I might've missed it."

Notecards for Your
BEAUTIFUL
MOMENTS JAR

Celebrate those everyday things that make you happy for no reason at all.
Write them down on these notecards, tear them out, and save them in a jar.
Pull one out every now and again to revisit and cherish a moment.

BEAUTIFUL MOMENT

date

flow·
(workman)

BEAUTIFUL MOMENT

date

flow·
(workman)

BEAUTIFUL MOMENT

date

flow·
(workman)

BEAUTIFUL MOMENT

date

flow·
(workman)

BEAUTIFUL
MOMENT

date

BEAUTIFUL
MOMENT

date

BEAUTIFUL
MOMENT

date

BEAUTIFUL
MOMENT

date

BEAUTIFUL
MOMENT

date

BEAUTIFUL
MOMENT

date

..

..

..

..

flow
workman

BEAUTIFUL
MOMENT

date

..

..

..

..

flow
workman

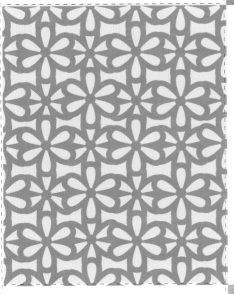

BEAUTIFUL
MOMENT

date

..

..

..

..

flow
workman

BEAUTIFUL
MOMENT

date

..

..

..

..

flow
workman

BEAUTIFUL
MOMENT

date

..

..

..

..

flow
workman

BEAUTIFUL
MOMENT

date ...

...

...

...

...

...

flow·
(workman)

BEAUTIFUL
MOMENT

date ...

...

...

...

...

...

flow·
(workman)

BEAUTIFUL
MOMENT

date ...

...

...

...

...

...

flow·
(workman)

BEAUTIFUL
MOMENT

date ...

...

...

...

...

...

flow·
(workman)

BEAUTIFUL
MOMENT

date
..

..

..

..

..

..

BEAUTIFUL
MOMENT

date
..

..

..

..

..

..

BEAUTIFUL
MOMENT

date
..

..

..

..

..

..

BEAUTIFUL
MOMENT

date
..

..

..

..

..

..

**BEAUTIFUL
MOMENT**

date

..
..
..
..
..

**BEAUTIFUL
MOMENT**

date

..
..
..
..
..

**BEAUTIFUL
MOMENT**

date

..
..
..
..
..

**BEAUTIFUL
MOMENT**

date

..
..
..
..
..

**BEAUTIFUL
MOMENT**

date

..
..
..
..
..

BEAUTIFUL
MOMENT

date
...
...
...
...
...
...

flow
workman

BEAUTIFUL
MOMENT

date
...
...
...
...
...
...

flow
workman

BEAUTIFUL
MOMENT

date
...
...
...
...
...
...

flow
workman

BEAUTIFUL
MOMENT

date
...
...
...
...
...
...

flow
workman

BEAUTIFUL
MOMENT

date
...
...
...
...
...
...

flow
workman

BEAUTIFUL MOMENT

date

..

..

..

..

..

BEAUTIFUL MOMENT

date

..

..

..

..

..

BEAUTIFUL MOMENT

date

..

..

..

..

..

BEAUTIFUL MOMENT

date

..

..

..

..

..

Between Going and Staying

Between going and staying the day wavers,
in love with its own transparency.
The circular afternoon is now a bay
where the world in stillness rocks.

All is visible and all elusive,
all is near and can't be touched.
Paper, book, pencil, glass
rest in the shade of their names.

Time throbbing in my temples repeats
the same unchanging syllable of blood.

The light turns the indifferent wall
into a ghostly theater of reflections.

I find myself in the middle of an eye,
watching myself in its blank stare.

The moment scatters. Motionless,
I stay and go: I am a pause.

Octavio Paz
The Poems of Octavio Paz, translated by
Eliot Weinberger (New Directions, 2012)

Celebrate the Wait

by Lissette Thooft

We want to see a movie and—ta-da!—we download it.

We're craving strawberries; they're available, even in winter.

We want to see our friends across the world: Skype!

We hardly have any time to savor anticipation anymore.

Recently my friend Micky decided to wait a week before buying a book. "I passed by the bookstore a few times, longing for that book," Micky said. "That gave me another seven days of enjoyment. It was so much more fun than getting it right away."

Oops, I thought. I always buy a book right away, as soon as I decide I want it. Then it usually stays on my growing pile, because there are so many other books that I really needed right away. Would it be different if I postponed buying it and looked forward to it for a while?

"Things and experiences gain value when you have to wait for them," says Harold Schweizer, professor of English at Bucknell University and author of *On Waiting* (*Thinking in Action*). "Instant gratification makes them worth less."

Anticipation is also good for you, say the experts. It makes your brain produce dopamine, and that makes you feel excited and happy. Research shows that people are happier looking forward to a vacation than during the actual vacation itself. And the more you allow yourself to anticipate something, the easier it is to overcome any obstacles that may present themselves on the way to that something. At least, so long as you don't get stuck in unrealistic fantasies.

CHILDLIKE MAGIC

Remember as a child how you felt just before you went on vacation? Or when it was nearly your birthday? Why don't I look forward to things like that anymore? Occasionally I'll have a fleeting thought, like: Oh, I'm going out for dinner tonight, that's nice. But usually I'm too busy to dwell on the good things of the future. Mostly I want it all right now.

"Impatience is a form of greed," Schweizer tells me. "Perhaps patience is like generosity: an act of generosity to give yourself the time to wait for something."

Social psychologist and author Susanne Piët is an advocate of cultivating anticipation. "If you're very rich or influential, you can get anything you want right away," she says, "but that often leaves people feeling empty and disappointed. The multimillionaire Jean Paul Getty said he once got a box of crayons for his birthday and that it was the best present he'd had in years. It was just a small gift, but it had to do with something that he could anticipate. And of course, it recalled childhood memories. Anticipation is an innocent, naïve state that all children know and one that is in danger of disappearing later in life."

Maybe I've been protecting myself, I think. Childlike magic is

> ## Research shows that people are happier looking forward to a vacation than during the actual vacation itself.

enviable, but what if the big event doesn't bring everything you've dreamed and hoped for? My eighth birthday, for example, was a disaster in slow motion. We had just moved and I hadn't made many friends at my new school yet. Also, my mother hadn't prepared anything special for my birthday: no games, no balloons, no scavenger hunt. Only two girls turned up at my party. One had a gift—a piece of soap, I think. We ate the cake. And that was it. I was deeply disappointed, but tried immediately to push that awful feeling away. Of course, it was my own fault, I thought, because if I hadn't been so full of anticipation ("Just three more days, just two more days . . ."), it wouldn't have hurt so much.

Maybe that's when I trained myself not to feel anticipation and to keep my expectations lower instead. "We'll see," I frequently say indifferently about an important event coming up. "It will probably pour rain." And I think: I won't fall into that trap anymore.

INSTANT GRATIFICATION

Nowadays, it's all about instant gratification. Everyone is quick to tell you that you no longer have to wait for fun things: You can get everything you want right now. It's no longer "only natural" to save money for a long time to be able to buy a luxury item. If you can't afford it, just use credit. Why wait? As a child, I had to nag for years before I finally got a guitar from my parents—and that was quite normal. When I became a mother and my teenage son decided that he wanted to learn to play the guitar, he scored a fine instrument online in just one afternoon.

Part of it is that technology today is at our beck and call, serving us faster and faster. Waiting for a letter just can't compete with all those smartphones and iPads full of emails, text messages, and chat apps. If people have to wait, no matter how briefly, they get out their smartphone: Has anything come in? Research shows that some people even check their phones often during sex. Instant gratification has invaded all areas of life.

In an interview comedian Louis C.K. did a bit that's known today as "Everything's Amazing and Nobody's Happy." He talked about how impatient we've become as a result of technology.

"Like, in my lifetime the changes in the world have been incredible," he said. "When I was a kid we had a rotary phone. We had a phone that you had to stand next to, and you had to dial it . . . You actually would hate people with zeros in their numbers—you'd be like 'Uh this guy has two zeros, screw that guy.'"

He went on to describe that he was once on a plane (in the early days of in-flight WiFi) where they announced that high-speed Internet was available for passengers. "That's the newest thing that I know exists," he said. "And I'm sitting on the plane and they go, 'Open up your laptop, you can go on the Internet.' And it's fast and I'm watching YouTube clips—it's amazing—I'm in an airplane! And then it breaks down, and they apologize, the Internet's not working. The guy next to me starts cursing. Like, how quickly the world owes him something he knew existed only ten seconds ago."

Now, no matter how quickly things are improving our lives, we are almost instantly disappointed that they're not happening faster.

DELAYING THE PLEASURE

Maybe we're losing an important quality: the pleasure of delayed gratification. In the infamous Stanford marshmallow study of the late '60s and early '70s, children were given a marshmallow that they were told they could eat right away, but if they could wait fifteen minutes, they would get two marshmallows. Less than a third of the children could summon up the patience to wait for the second marshmallow. Years later, a

NINE WAYS TO PROMOTE ANTICIPATION

* Reread a book of poetry
* Clear out your closets, leaving them empty afterward
* Set a fixed evening to watch a TV show
 (instead of bingeing on three episodes at a time)
* Pick fresh strawberries in the spring
* Mail a letter to someone (and wait for the answer)
* Take an old analog camera with you
 instead of a digital one
* Send dinner invitations in the
 mail (rather than online)
* Start a new blank diary
* Make vacation plans

follow-up study showed that the kids who waited did better on all fronts: They got better grades at school, and they were more capable, healthier, and happier.

"Because of ubiquitous instant gratification, something paradoxical happened in our society," says Dutch author Mark Mieras in *Liefde* ("Love"), a book that explores the neurobiology of craving. "Because we have so little time to long for something, there is a kind of restlessness in our lives which leads to us enjoying ourselves less," he says. "If you always get everything you want right away, you're constantly on the treadmill of dissatisfaction, always on the lookout for the next product, the next set of new clothes, the next gadget, without ever reaching the stage of quiet enjoyment and being satisfied with what you have."

Postponing pleasure can be wonderful. And it doesn't have to be for big things—you can do it all the time in daily life. What's better: grabbing a quick sandwich that's available on the supermarket shelf or sitting down to a meal that you've planned, prepared, and served over several hours? Of course, you can eat faster, but you won't savor the experience in the same way. There's nothing wrong with casual encounters or spontaneous parties, either—but a party or a date that you can really anticipate for a while makes you feel that life is worth waiting for.

The Joy of
ONE THING AT
A TIME

In today's busy world, it's often hard to find time to devote our attention to a single task. We want to do *everything*, and sometimes it's so paralyzing that we end up doing nothing.

These days we really excel at doing three or four things at once. We pack lunchboxes while having breakfast and put on our mascara while checking email. We can do it. We can also buy a birthday gift online *while* the TV is on and *while* we are sending a text message and *while* we are helping with homework. We can empty the washing machine while taking a work call and making a shopping list. But how much fun is it to be able to do all this?

Reading a book, enjoying a warm cup of tea, and listening to a friend are all things that don't mix well with our effective multitasking. It turns out that doing one thing at a time can be more peaceful and fulfilling. Because we enjoy what we do, and we see and experience much more this way.

So here's to not trying to do it all at once. This booklet, full of insights about what concentrating on only one thing at a time can give us, can actually guide each of us to trim away the excess and do it.

THE JOY OF
ONE THING
AT A TIME

notebook

"Do not go where the path may lead,
go instead where there is no path,
and leave a trail."

—Ralph Waldo Emerson

THE COMFORT ZONE

Step Out of Your
Comfort Zone

by Caroline Buijs

They say that life begins at the end of your comfort zone
and that there are benefits of living with some uncertainty.
But how do you identify your own zone so you can move beyond it?

Once, on my very first trip abroad to India, I literally came into contact with the perimeters of my own comfort zone. At the hotel where I was staying in Delhi, there was a tropical garden paradise in the shade of palm trees, with sun beds, cocktails, and a gorgeous, clear pool. But the moment I stepped outside the hotel's gate, I found that the city was hot, dusty, and noisy, and there was a long line of rickshaw drivers shouting at me, "Lady, lady, rickshaw, rickshaw!" Frightened, I immediately ran back into the hotel garden like a child.

No matter how boring or painful your comfort zone is, if nothing tempts you out, you'll stay where you are.

On my second day, I still could not manage to exit the hotel, and I found myself enjoying the pool, but not quite as happily. I knew there was a world out there that I'd come to explore, but I couldn't get past my fear of going out into it. On the third day, I realized that if I wanted to see more of India than just a swimming pool, I *had* to get out of that garden.

I started with the safe route, booking an organized city tour with other travelers through the reception desk. The following day, I worked up a little more courage and took a taxi to a nearby temple by myself. Finally, on the last morning of my trip, I walked out to that line of rickshaw drivers and asked one to take me to the market, only to discover that the ride was not at all scary, but actually very exciting. It was thrilling to be out on my own and to see the real life of India, rather than the safe haven of the hotel. Having new experiences felt good: I actually enjoyed feeling a little bit lost.

COMFY STRAITJACKETS

"What you know and what you're used to feels familiar, and that's your comfort zone," says Pieternel Dijkstra, a Dutch psychologist, researcher, and writer. "Breaking out of it means taking risks. You don't know what to expect, and many people find the uncertainty especially difficult because they're very focused on safety. Consciously or unconsciously, we want to stay in control of ourselves and our feelings."

It's different for every one of us, that comfort zone. Perhaps your sister has no trouble addressing a room full of strangers (most people's greatest fear), but when it comes to attempting something creative, she can't even begin. Or your best friend is a great adventurer when it comes to bungee jumping or running naked into the surf, but at work she can't get up the courage to ask her boss for a raise. Even when we're incredibly confident in some ways, fear is part of what makes us human.

Because fears differ from person to person, there are also degrees of discomfort as people leave their comfort zones. "For some people, it's a very tight space, almost a straitjacket that you can't get out of," says Dijkstra. "Often, these people live very methodical lives. You'll see that more flexible people have a more roomy comfort zone."

I began to wonder: What defines our comfort zones? And why do we tend to opt for safety and security in certain areas, rather than seek out experiences that will expand our world?

Dutch career counselor, life coach, and photographer Frederike Dekkers says that some uncertainty is healthy. "People who are never uncertain aren't prepared to examine themselves," she says, "and if you never allow uncertainty into your life, you will become inflexible."

Sticking to our comfort zones can prevent us from leaving our hotels on our vacations, or it can have

more serious and long-lasting effects: It can keep us in a dead-end job, prevent us from ending a destructive relationship, or make it impossible to stop negative behaviors like smoking or using drugs.

SOURCES OF GRATIFICATION

Psychologist and workplace consultant Judith Sills is the author of *The Comfort Trap*, a guide to changing patterns and habits that are only leading to dead ends. She writes that there are sources of intense gratification that lie just beyond the boundaries of our comfort zone:

- *Intimate relationships:* Within a relationship it's necessary to be very honest, and that can feel uncomfortable.

- *Sexual satisfaction:* Daring to admit your sexual desires and needs is not easy for everyone.

- *Sports performance:* Just think of that slight aversion to exercise you feel before you start.

- *Major objectives:* These are big steps, like taking on a new job or moving to an unfamiliar city.

Comfort is so attractive because it's safe, but security limits the satisfaction that a new experience can give you. And everyone needs to go on having new experiences, if only because they make our lives seem longer. New experiences provide new memories that can comfort you when times get tough. They also provide you with a breath of fresh air, a little bit of space in your head, so you can see the world with a new kind of clarity.

"We need to feel comfortable to live fully, yet if we're too comfortable, something essential dies," Sills writes. "A life that is too much work erodes the body, but a life that requires too little effort depletes the

TIPS FOR BREAKING OLD HABITS

There are many paths toward making change. Sometimes it's about stepping a little outside the box once or twice, and other times, it's a more sustained action. But timing can be everything: Psychologist Roy Baumeister recommends making changes when things are going well in your life.

* Take a class. (A carpentry course? A philosophy lecture series?)

* Tell the truth. (But don't be rude about it.)

* Order a drink that you've never tasted before. (A minty mojito? A pomegranate smoothie?)

* Take a lesson in a sport you've never tried. (Horseback riding? Fencing?)

* Try a weeklong media blackout. (No reading, watching TV, or surfing the Internet.)

* Read a completely different magazine.

* Keep a diary. (Even if they're small, write down your goals and record what you're doing.)

Like everything, it takes practice to get good at making change. Baumeister says that no matter what behavioral change you're aiming for, the fact that you are introducing a change already has an effect. If you start with something simple, it will prepare you for the bigger challenges.

soul. Between these two extremes there is a harbor, a state of psychological grace, a platform of emotional well-being. It is your comfort zone. It's a haven. And by its nature, it is temporary."

START STRETCHING THE LIMITS

The benefits of sailing out of your haven for a little while are enormous, according to psychologists.

To begin with, if you are always doing the same things because they're safe, you may not be seeing any progress in your life. In *Waiting for Godot,* Irish playwright Samuel Beckett's character observes, "[H]abit is the great deadener." Albert Einstein also weighed in on the subject: "Life is like riding a bicycle. To keep your balance, you must keep moving."

Here's another benefit of allowing yourself to experience different things: Doing something new requires your full attention because it's unusual, leaving little room in your mind for worrying. Small things that might normally bother you start to become unimportant and tend to disappear.

So, how do you exit your comfort zone? Psychologists say that it's much easier to start to stretch or bend the limits of your comfort zone by breaking daily habits in easy little steps. You can do this, for example, by taking a different route to work some days, or eating breakfast at a restaurant for a change, or taking yourself to the movies, or cooking once a week with ingredients that you rarely use. Once you start making little changes in your life, it's easier to get used to the idea of taking bolder steps.

"One big step is too scary," says Dijkstra. "You must prepare well for change. If you try doing it in one step, you often fail. Then you have a negative experience that won't encourage you to give it another try. By carefully preparing yourself, you increase the chances of having a successful experience. And that gives you more strength the next time."

CULTIVATING COURAGE

Marianne Elliott, an author, human rights advocate, yoga teacher, and photographer from New Zealand, spends a lot of time thinking about courage and teaching people how to break out of their comfort zones. In her book *Zen Under Fire,* she tells the story of her UN peacekeeping mission to Afghanistan and how living in an incredibly stressful environment changed her relationships and taught her about what it means to cultivate courage. On her blog, she guides people through a "30 Days to Courage" program "for people who want to step out of their comfort zones, through the small acts of daily bravery that add up to a courageous life" (marianne-elliott.com).

Elliott says, "There are times when life will put you in a situation where you have to take a big step. But if you have been cultivating your capacity to make courageous choices in small ways, you'll be ready to make it."

Courage isn't always what you might think it is, according to her. It's not about being tough, strong, or confident, and it's not a personality trait, either. "There's always a relationship between courage and vulnerability, because stepping out of our comfort zones inherently means stepping into a place where we feel vulnerable," she says. "It's a place where we don't know yet what's going to happen, and one of the possibilities is that we experience something that we don't enjoy, like rejection or failure."

Elliott herself doesn't even identify as particularly courageous, in spite of the fact that she does look quite brave from the outside. "Every courageous choice I've ever made has been about being afraid," she says. "If we're not feeling vulnerable, it's guaranteed that we're not feeling courageous."

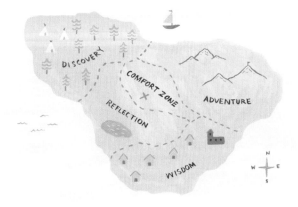

"SCARY" VERSUS "EXCITING"

When you allow yourself to be vulnerable and drum up the courage to step out of your comfort zone, chances are you'll meet your inner critic. "It's a kind of dragon guarding the gate of your comfort zone, telling you things like, 'You don't have to leave, just stay nice and cozy where you are,'" says Dekkers. "Be aware of the dragon and don't let it stop you. You'd be better off thinking, 'Oh yes, I'm scared. It's terrifying, but that's just part of it.'"

Her simple but effective trick for beginning to cope with fear and uncertainty: Don't call what you're doing "scary"; call it "exciting." That immediately alters your attitude about the change.

Elliott goes a bit further. In her experience, the inner critic isn't just a voice that tells us, "This is not safe." It's a voice that says, "It's not safe because you're not up to this, because you're not strong enough, smart enough, or something else." It's a demoralizing, demotivating voice. And as you walk toward the edges of your comfort zone, that voice gets louder. "I've worked with people who tell me that when the voice gets louder they think it's their intuition telling them not to go there," says Elliott.

HEARING VOICES

"We need to recognize that the inner voice of the critic is different from our intuitive, wise, inner voice," Elliott says. "One way you can tell the difference between the two is that the inner critic—that fearful voice—tends to make a catastrophe out of it. So the message you might get is, 'You could completely fail and humiliate yourself; it will be a disaster.'"

An intuitive voice, Elliott continues, might also be your gut telling you something is unsafe, but your intuitive response is more likely to suggest taking certain precautions—doing some background research, for example—or otherwise preparing yourself physically, emotionally, or intellectually for a new challenge. "There's a difference between the voice that is making sensible suggestions about the steps you need to take to ensure you succeed, [and] the voice that is trying to

scare you into not doing something altogether," she says.

Taking a moment to stop and listen to the voice and its tone will help you distinguish between the useful guard and the nay-saying critic. Once you do, it won't hurt to take some of the advice of your friendly, intuitive voice. But don't spend any time or energy combating the critic in your head. "You don't have to fight that voice or argue with it," Elliott continues. "You just have to cultivate the other voice, the inner sweetheart, that supports and encourages you, that says, 'It's okay, Marianne, just keep going.' For me, that's been huge."

A CREATIVE OUTLET

According to Sills, another great help in getting out of that comfort zone is knowing what you want. "No matter how boring or painful your comfort zone is, if nothing tempts you out, you'll stay where you are," she writes. "If that desire doesn't make itself known, you should go out and look for it," she continues. And how do you do that? Sills says we need to seek creative outlets, "because suppressed desire lives in the subconscious mind and the creative process gives [us] access to it."

In her book *The Artist's Way*, Julia Cameron presents a proven method for uncovering your desires. She loves working with lists and suggests you ask yourself simple questions:

* If I didn't have to do it perfectly, I would . . .

* If I dared to be a beginner, then . . .

* Things I would never try, but sound like fun are . . .

The prompts work especially well if you fill them in quickly and don't think too much about the answers.

So, we just have to challenge ourselves to cross that threshold at times. Fear is part of it, but not the only part. As Nelson Mandela once said: "I learned that courage was not the absence of fear, but the triumph over it. The brave man is not he who does not feel afraid, but he who conquers that fear."

Enough

Enough. These few words are enough.
If not these words, this breath.
If not this breath, this sitting here.

This opening to the life
we have refused
again and again
until now.

Until now.

David Whyte
Where Many Rivers Meet
(Many Rivers Press, 1990)

The New Wisdom of
Pleasant Propaganda

by Dorine Verheul

When a long-forgotten World War II propaganda poster resurfaced, it brought daily inspiration into the twenty-first century and sparked the creation of new motivational posters by clever contemporary designers.

It is 1939 and all is uncertain. On September 3, England and France will declare war on Germany and World War II will begin. Just as the British government is gearing up for conflict, it commissions the printing of 2.5 million posters. They carry a message to strengthen the morale of the people: "Keep Calm and Carry On." For reasons unknown, the poster never makes it out of the printer's warehouse. However, two other government-commissioned posters, "Freedom Is in Peril" and "Your Courage, Your Cheerfulness, Your Resolution Will Bring Us Victory," do hit the streets.

Sixty-one years pass, and in 2000 an English bookseller buys some boxes of books at an auction. In one of the boxes is a poster with the message "Keep Calm and Carry On." The bookseller and his wife hang the poster in their store. Soon customers ask if they can buy a copy, and the bookseller gets some printed. They sell well, and in 2005 the poster is included in the Christmas special of a national newspaper. From that moment on, there's a mad rush to "Keep Calm." The

bookseller's website crashes, bombarded by all the online interest, and the phone rings off the hook.

The message resonates across the Western world, and in no time the long-hidden poster shows up everywhere: on lifestyle blogs, in magazines, and on the walls of the finest homes.

AN EYE FOR BEAUTY

Long before "Keep Calm" appeared on the scene, people shared touching lines of wisdom on their walls as reminders of the important things in life. Grandma's "Home Sweet Home" needlepoint was as common and reassuring as the smell of home-baked pie. But around the world, the modern inspirational poster was a yawn-inducing bore that failed to motivate and was often found hanging in the corridors of office buildings: a cat swinging from a tree branch, for example, reminding people to "Hang In There."

The arrival of "Keep Calm" changed all that. From the moment it appeared, people saw that an

Reflections on the
Power of Screen Time

Interviews by Renate van der Zee

It seems that everywhere we turn these days—in cafés, on the train, out on the street, and even at home on the couch—people are staring at little screens. Why is social media so addictive? And is it a bad thing? We asked a psychologist, a new media expert, and a professor to weigh in.

UNPLUG AND UNWIND

by Tony van Rooij, psychologist and addiction researcher

"Smartphones create restlessness and lack of focus, but I don't think you can really call it a serious addiction. When you're addicted, you can't control your own behavior; you can't function properly. Despite it being annoying when people are looking at their phones all the time, it doesn't mean they're addicted.

"Research among young people has shown that five to six percent really have trouble controlling their telephone behavior. But I think it's more a matter of habit-forming behavior than of addiction. People are sensitive to instant rewards, and that's what the phone offers (a message, a 'like' on Facebook). Conversely, let's say I've been working hard on a report—the reward won't come until weeks later when it's read, so the impulse for wanting to feel something sooner is understandable. It helps to be aware of the fact that there's a lot of commercial thinking going on behind all those little beeps on your phone. Facebook *wants* you to look at your page

> Fifteen years ago, no one wanted to be available 24/7. Now we feel practically incapacitated if our phone breaks. So, turn it off now and then.

often so that you will see the ads. So ask yourself this: What does this do for me?

"Fifteen years ago, no one wanted to be available 24/7. Now we feel practically incapacitated if our phone breaks. So, turn it off now and then. I pull the Internet cable out of my computer from time to time. Otherwise I'd be checking the news sites all day long,

inspirational poster could be an authentic thing of beauty; it could be sincere and not corny or preachy. Filled with inspiration, designers and illustrators picked their favorite quotes, and genuine wisdom began rolling off the presses.

One such gem spinning around the world via the Internet is a design by Australian photographer and filmmaker Hailey Bartholomew. She was racking her brain for a small gift she could send to her clients to thank them for their commissions when she remembered something one of her clients had once said. She had been making a film about love and was interviewing a married couple when Hailey asked about the secret of their success. The man replied, "The grass is greener . . . where you water it."

"I was charmed by what he said," Hailey remembers. "It's so easy to look around and think that others have got it better than you—a better job, more attractive partner, and so on. But if you pay attention and care for what you already have, it's just so beautiful how it can grow. It made me see very clearly what I was forgetting to do in my own life."

In early 2012, Hailey and a friend created a design for the quote, and printed cards and posters to send to clients. The response was enthusiastic. Hailey posted the design on her blog, and soon other bloggers, Facebookers, and Pinterest users were sharing it in their own online spaces.

The same thing has happened with the work of many other illustrators and designers—like Elisandra, one of *Flow* magazine's favorite illustrators, who regularly illustrates quotes.

"I choose quotes that I really don't want to get out of my head," she says. "These lines get in there and demand to be illustrated, like the beautiful line from Anaïs Nin: 'And the day came when the risk to remain tight in a bud was more painful than the risk to bloom.'" Elisandra feels that more and more people are looking for meaning and significance. "They've rediscovered that superficial beauty is not enough. They want to be reminded of something that has meaning, and that's why they'll buy a quote for the wall."

SUCCESS IN A TIME OF CRISIS

American designer Jen Renninger agrees that people like having motivational words hanging on their walls to point them back to what they find important in life. Jen makes lots of posters with positive messages. "Everything Is Going to Be OK" was a huge bestseller, for example. "I made the poster when I'd just been diagnosed with arthritis and was pretty much in pain every day," she says. "If I had problems walking, or had yet another bad reaction to the drugs, then I'd repeat these simple words like a mantra. They helped me get through it: I said I'm going to keep on repeating this until my disease is in remission."

To this day, the poster hangs in Jen's home. Copies really started selling after December 2007, when the economic crisis finally broke in America. "I saw this pattern repeating as the economic crisis hit each subsequent country," she says. "Suddenly there would be more orders from that country. In fact, sales decrease slightly when things go better in a country." Jen thinks it all goes back to that little kick "Keep Calm" gave to the genre. "Since then, the ball started rolling and we're experiencing a momentum that doesn't seem to want to stop."

1 *by Jen Renninger*
etsy.com/shop/pleasebestill

2 *by Elisandra*
etsy.com/shop/sevenstar

3 *by Lisa Congdon*
esty.com/shop/lisacongdon

flow
workman

and thereby missing the deeply fulfilling things for which I have to concentrate a little longer."

DRAW THE LINE

by Arjen van Veelen, new-media expert and journalist

"I was once driving in Mississippi through a gorgeous forest blazing with autumnal colors. I didn't have any Internet access, so I couldn't share my experience on Facebook. I thought that was a shame, but I also realized there was something quite pleasant about it. Today, things have progressed to the point where people have started doing things for the sake of putting them on the Internet. Should we be worried about this? I don't think so.

> ## Social media can give you . . . [a] kind of primal affirmation.

"Social media can give you confirmation that you exist, that you matter, and that's what people need to hear—that kind of primal affirmation. We just need to set boundaries. When the first car was invented, people said, *It's too fast, that's dangerous!* They were right, and that's why brakes, seat belts, and airbags were invented. That's the stage we're in now with social media: It's time for airbags. My strict rule is that I can't bring my phone with me to the bedroom. I also installed software that allows me to block Internet access for a certain period of time. Otherwise, it's nearly impossible to do work on a machine that also functions as an endless playground! Mere discipline isn't enough to resist that.

"But the phone also has advantages. Before, conversations would just stall sometimes. Now, there is always a funny picture to show or some interesting clips to share. And when I miss my train, I'm glad I can talk to my friends on the phone and don't have to just stare out at the empty train track."

STRIKE A BALANCE

by Patti Valkenburg, professor of media, youth, and society, University of Amsterdam

"Social media has gotten closer and closer to us, physically speaking. First it was just on the computer, which was on our desks. Then we got laptops, which we could carry around with us in our bags. Now, with the smartphone, the world of social media is literally in our pockets, and it is now more specifically designed to continuously attract our attention. It's pretty easy to do so, because we humans have a built-in reward system encouraging us to respond. Stimulation, or even the mere expectation of it, initiates the production of dopamine, the chemical associated with reward and pleasure. For some people, the beeps and blips on phones really generate a sense of excitement. The effect is powerful and hard to resist. It could be addictive, in theory, but we don't know enough to say that yet.

"What we do know is that it's important to get offline now and then. In addition to a good night's sleep, people need time for their minds to rest during the day. As part of a beginning countertrend, large companies are now making agreements with their employees that they don't have to be available all the time.

> ## We have to limit ourselves to keep it balanced.

"Of course, social media doesn't only have drawbacks; it's fantastic that we can communicate with people effortlessly everywhere, no matter how far away they are. But we have to limit ourselves to keep it balanced. That is the collective challenge."

TIME TO LEARN

Over the years of working together to grow *Flow* magazine, our biggest lesson has been how great it is to keep learning. Isn't it strange that we have been through all these years in school, studying mathematics, science, and economics, but we never learned how to live our lives? So, we keep practicing. Many of the specific lessons we've learned over the years come directly from mindfulness courses that we have each taken. The courses helped us gain perspective and allowed us to recognize that the self-critical thoughts we both found ourselves falling for are just that: thoughts. We learned that if you don't identify with them, but look at them from a distance, they don't feel so big and bad. And we learned that we feel much more balanced if we go for a run now and then, or meditate.

Or make a simple change like keeping our cell phones out of our bedrooms or taking up drawing lessons—or signing up for a silversmithing course or practicing self-compassion. This is our attempt, as many mindfulness teachers will describe, to look at the world with a beginner's mind. If we make ourselves open to new ideas and thoughts, we can be better problem solvers, more creative thinkers, and more empathetic people.

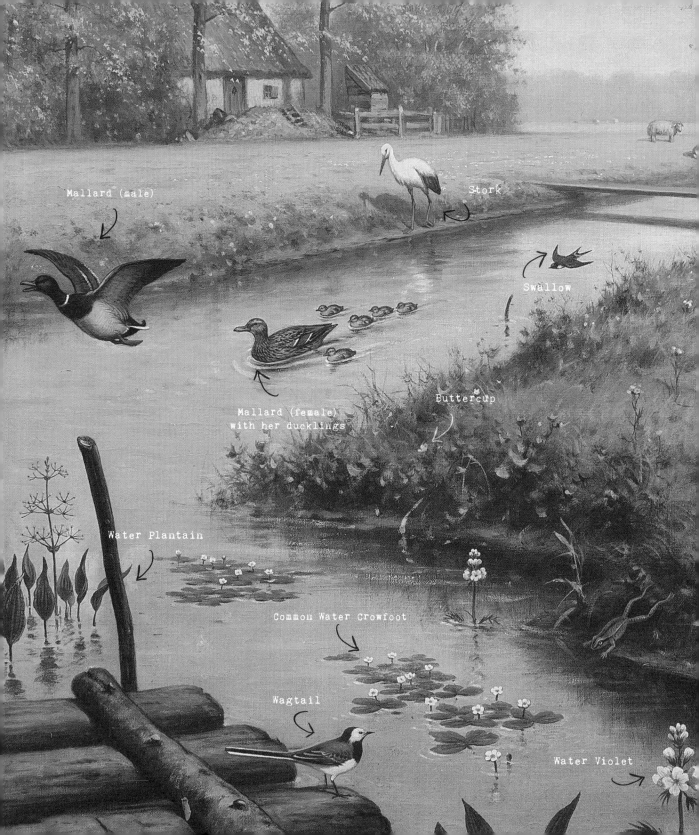

Mallard (male)

Stork

Swallow

Mallard (female)
with her ducklings

Buttercup

Water Plantain

Common Water Crowfoot

Wagtail

Water Violet

Rook

White Willow

Lapwing

The One with the
Yellow
Leaves

by Caroline Buijs

It's strange, really, that we often don't know
the names of the wildflowers that grow near
our homes or the birds in our gardens.
A whole new world opens up when
we get even a smidgen of nature knowledge.

Comfrey

Mole

In the first half of the twentieth century, it was still fairly common to go into the great outdoors to pick wild plants.

When I used to go cycling through the fields with my eighty-five-year-old father, he could effortlessly name all of the plants we saw: oats, barley, corn, etc. When we'd stop to eat a sandwich on a patch of grass, he knew the name of each and every wildflower. It never ceased to amaze me, because my own botanical knowledge is limited to: "It's so lovely and . . . green!"

I'm not the only one who doesn't really know much about what's growing and blooming. We have all, in the course of a single generation, become much more removed from nature.

In 2013, a nonprofit platform in the UK called Greeniversity conducted a survey asking people to identify the top skills people had sixty years ago that they felt were on the verge of being lost. The top three were: 1) repairing household items, 2) wildlife identification, and 3) foraging for wild food.

In the first half of the twentieth century, it was still fairly common to go into the great outdoors to pick wild plants to supplement your diet—which was particularly crucial in harsh climates. Without refrigeration in those days, people had to get their vitamins from pickled foods like sauerkraut, salted beans, and corned beef.

When spring came and you'd been eating this monotonous diet for months, you'd go foraging for nettles, sorrel, and dandelions to get your greens and elevate your vitamin levels. Depending on the season, you'd use what nature offered: elderflowers, elderberries, wild garlic, blackberries, spearmint, chamomile, chestnuts, crab apples, and more. Wild foraging wasn't just about the food; it was a social activity.

Picking wild plants has become redundant, thanks in large part to the rapid development of agricultural technology after the Second World War, and so the tradition of foraging has died out in a single generation.

THAT NICE BIG TREE OVER THERE

They say that children between the ages of five and twelve are particularly impressionable, and they're especially impressed by nature. That, too, may explain my lack of familiarity with nature. The house I grew up in was once across the road from a field of heather, but it was soon replaced by a row of houses. A grass field right next to our home was also developed shortly thereafter. Maybe that was when I lost interest: Nature was mostly something that tended to disappear.

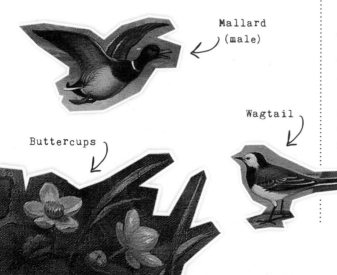

Mallard (male)

Buttercups

Wagtail

It wasn't until I was thirty that I started to appreciate the joys of walking. I finally stopped asking, "Are we there yet?" and discovered that the whole point was the walking itself. I also noticed that my mind became pleasantly peaceful when I was surrounded by greenery. But what I was actually surrounded by, I had no idea! I could tell a poppy from a dandelion, but really didn't know much more than that.

Victoria Price, a UK-based officer at Fauna and Flora International, a conservation and advocacy group that tries to protect endangered species and ecosystems worldwide, says that people used to have a lot more basic household knowledge about plants, in part because we used our local plants for medicinal purposes. "People have lost information about animals and birds, but with plants, in particular, people just aren't aware of how to identify the species anymore—let alone identify their medicinal properties," she says. "The decline of agriculture and the move away from the land has resulted in people not knowing the plants they're surrounded by."

And that's a pity, says Marjoleine de Vos in the Dutch newspaper *NRC Handelsblad*. Sometimes, the plants right around us can be incredibly useful—not to mention pretty. "Knowledge is also a joy for its own sake. Knowing more about something makes the world a richer place. For example, to someone with a bit of botanical knowledge, those pretty flowers by the road are a lively mix of cow parsley, yarrow, and yellow rattle. They actually see more, and that enriches their lives."

Journalist Caspar Janssen writes a beautiful description of what's good about knowing more than "a nice shade of green": "For years, I looked at dozens of trees, every day, without knowing any of their names. Sometime last year I got fed up with that. To start with, I wanted to know what that 'nice big tree' right in front of my house was called. I had been calling it a willow, even a lime tree, and no one ever corrected me. I finally took a leaf off the tree and placed it side by side with the illustrations from a tree book. No question now: It's a poplar. Small effort, great satisfaction. Since then, I've been getting to know all the trees and shrubs around me, and it's adding new dimensions, new conversations, and new stories to my life. Earlier, neighbors would

Eurasian Jay

say, 'Lovely, all those trees.' Now we discuss the colors of the chestnut and the goldenrain tree, the male and female catkins of the poplar, the blossoming of the magnolia and the rowan. Yes, you can definitely say that's enriching. In any case, it's made me very happy."

> Direct observation is the basis of all knowledge about nature. What it all boils down to is looking at things properly.

PAINTER'S SORROW

It's thanks to my son's school garden teacher that my own need to know more about nature has grown so much in the past year. He has fed my son's enthusiasm for zucchini plants, potatoes, and flowers like catkins and dahlias. He's made up fun activities like the Wondrous Winter Carrot Weighing Contest. In short, he is doing exactly what the founders of nature education were saying should be done one hundred years ago: making nature education tangible. Back then, teachers would take their classes outside, and in every classroom there was an aquarium and a terrarium, because they were of the opinion that direct observation is the basis of all knowledge about nature. What it all boils down to is looking at things properly.

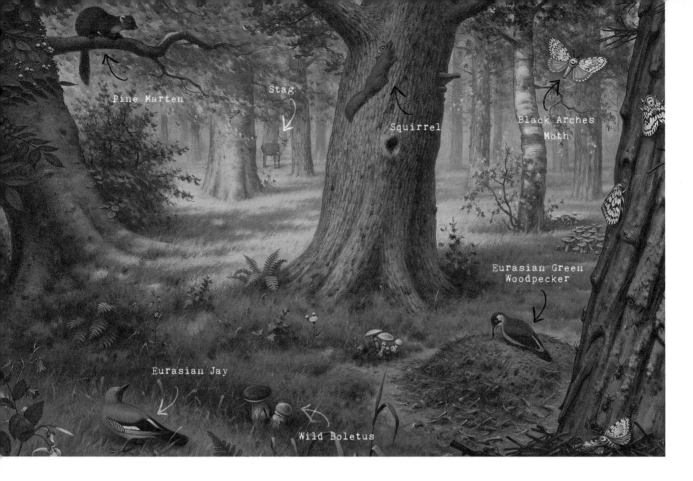

Pine Marten

Stag

Squirrel

Black Arches
Moth

Eurasian Green
Woodpecker

Eurasian Jay

Wild Boletus

DIGITAL RESOURCES FOR GETTING STARTED

The key to nature knowledge is going local: What's in your backyard (or on your street)
is not necessarily what's in backyards everywhere. So it's best to look for apps
that are local. Here are two examples of resources you can use:

✳ An international website called
ispotnature.org from the Open University
lets users take a photograph of unknown
fauna or flora, upload it to the site,
and ask the community to help identify
and verify observations.

✳ An app developed by Columbia University,
the University of Maryland, and the
Smithsonian Institution in the United
States, **Leafsnap** allows you to identify
a tree using visual identification
software. Just photograph a leaf and
it'll try to match up the image with the
correct North American species.

If you're interested in learning something about nature, you won't succeed if you're in a hurry.

The names themselves are reason enough to study plants. *Saxifraga x urbium*, for example, is called *schildersverdriet* in Dutch ("painter's sorrow"), because no painter ever succeeds in capturing its little flowers in oil paint. In English, it has various names, including London pride, St. Patrick's cabbage, whimsey, and prattling Parnell.

Lychnis chalcedonica is sometimes called burning love because it is so intensely red and, at other times, gardener's delight. Folk names for plants can also refer to the devil (hellweed), medicinal properties (plantain is called snakeweed in the United States, because it's thought to cure snakebites), the season of the plant's bloom (summer beauty, autumn indigo), or its shape and appearance (foxglove, grape hyacinth).

If you're interested in learning something about nature, take a breath—you won't succeed if you're in a hurry. Dutch conservationist and botanist Jac. P. Thijsse wrote, more than 100 years ago, "Don't be impatient; if you haven't achieved your goal within ten minutes, make it fifteen, a natural scientist always has time. . . . If you have ventured out in quest of a Goldfinch, it is quite possible it will not show itself to you. But you may be rewarded for your troubles by the unexpected appearance of a flock of Snow Buntings, a Green Woodpecker, or a Bohemian Waxwing."

AHA! A MOORHEN

But then, how do you improve on your knowledge of plant names? Just starting to memorize random lists of flower names seems like an endless task. You usually learn things quicker if you are having fun doing it, and that's true with nature knowledge too, according to Victoria Price.

"There're loads of different ways to do it, especially now that there are so many identification apps you can download online; and then you can take it outside with you and just have a go," she suggests. "Also a lot of nature reserves have educational programs that can take you bird-watching or bug spotting, and they often offer guided walks to identify trees. The environmental organizations and charities around you are good resources to start learning. Plus, there's a really active movement now with urban wildlife and green infrastructure to get wild landscapes into urban environments, which might be putting native species into roof gardens or even inside apartments."

Deciding on what exactly you want to learn more about also helps. Birds, trees, or butterflies? Or perhaps simply the names of the flowers in your garden or on your balcony.

I started with the park where I go for strolls during my lunch break, deciding to learn three new names on each walk. Depending on the season, I might pick a leaf or a flower, and when I'm home I look it up to find out its name. Sometimes I take a picture of a bird I don't know. This way, I recently managed to identify a moorhen, using my digital field guide. At home, my family teased me, and I know a moorhen isn't all that rare, but I didn't care. I felt like a detective, and the joy of finding out for myself the name of an unknown—to me—bird, tree, flower, or plant is what it's all about.

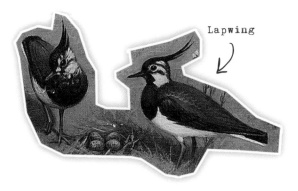

Lapwing

WHAT ARE YOUR VALUES?

To help find out what drives you, answer the first question below, and then continue asking why, what, and how.

1. What do you want from life?

4. What would doing that give you?

2. Why do you want that?

5. What do you like about doing that?

3. What would you do then, for example?

6. What could you do right now to get started?

Season to Taste

by Julia Rothman

Nowadays, you can buy pretty much anything you need at the store. This is often convenient for our busy lifestyles, in which we don't have a lot of time to make things from scratch. It's just *easier* to pick up a birthday cake at the bakery or stop by the grocery store's hot buffet for a quick lunch. But when we get in the habit of buying instead of making, we miss out on much more than the actual thing itself. We miss out on everything that the creative process can teach us. We miss out on the special value that comes from making something with your own hands.

The next time you're craving a homemade meal but think you don't have the time, give yourself permission to *make* the time. Pick up the ingredients, turn the music on, and savor those moments in your kitchen. These DIY spice blends will infuse your dishes with extra flavor, a delicious celebration of the joy that comes with all things homemade.

FENNEL
FLOWER

SEED

CLOVES

Chinese Five Spice

An aromatic blend with a little bit of heat thanks to the tongue-tingling sensation provided by the Szechuan peppercorns, which are unrelated to black pepper or chiles. This is usually used for rich meats or flavored oils, and ingredients vary by region.

CINNAMON
QUILLS

Mix the following:

1 TABLESPOON GROUND CINNAMON
1 TABLESPOON GROUND CLOVES
1 TABLESPOON FENNEL SEED, TOASTED AND GROUND
1 TABLESPOON GROUND STAR ANISE
1 TABLESPOON SZECHUAN PEPPERCORNS, TOASTED AND GROUND

STAR ANISE

THYME

Za'atar

A tart spice blend usually made with thyme, sesame seeds, and the tiny, sour, dark-red fruit of the sumac plant, which are dried and ground into a powder. Za'atar is often sprinkled on warm bread topped with plenty of good extra-virgin olive oil.

Mix the following:

2 TABLESPOONS MINCED FRESH THYME
2 TABLESPOONS SESAME SEEDS, TOASTED
2 TEASPOONS GROUND SUMAC
1/2 TEASPOON SEA SALT

SESAME
SEED
PLANT

SUMAC

PEQUIN
PEPPERS

Mitmita

Not as well known as the more complex Ethiopian spice mix called berbere, this blend of mostly chile is sprinkled on beans or blended with clarified butter to make the raw beef dish called "kitfo."

Grind the following into a fine powder.

½ POUND DRIED PEQUIN OR AFRICAN BIRD'S EYE CHILES

1 TABLESPOON BLACK CARDAMOM PODS, SHELLS REMOVED AND SEEDS TOASTED

½ TABLESPOON WHOLE CLOVES, TOASTED

¼ CUP SEA SALT

CARDAMOM
PLANT

PODS

SEEDS

Garam Masala

A go-to spice on the Indian subcontinent - garam roughly means "heat mix"- it varies from cook to cook and has plenty of warming spices.

Toast the following until fragrant, then grind into a fine powder.

4 TABLESPOONS CORIANDER SEEDS

1 TABLESPOON CUMIN SEEDS

1 TABLESPOON BLACK PEPPERCORNS

1½ TEASPOONS BLACK CUMIN SEEDS

1½ TEASPOONS GROUND GINGER

SEEDS FROM 4 PODS OF BLACK CARDAMOM

25 WHOLE CLOVES

2-INCH PIECE OF CINNAMON STICK, CRUSHED

1 BAY LEAF, CRUSHED

CUMIN

GINGER

BAY LEAVES

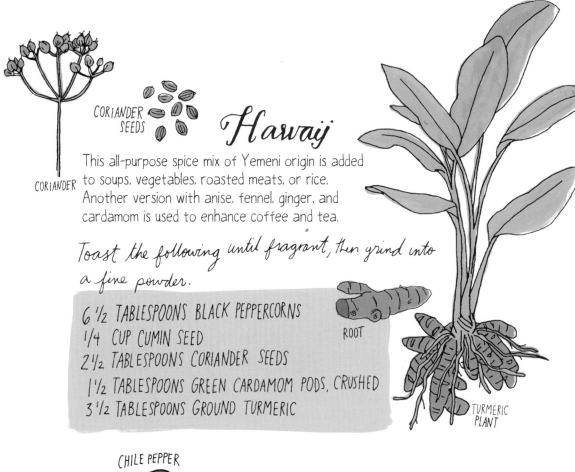

CORIANDER SEEDS

CORIANDER

Harwaij

This all-purpose spice mix of Yemeni origin is added to soups, vegetables, roasted meats, or rice. Another version with anise, fennel, ginger, and cardamom is used to enhance coffee and tea.

Toast the following until fragrant, then grind into a fine powder.

ROOT

TURMERIC PLANT

6 ½ TABLESPOONS BLACK PEPPERCORNS
1/4 CUP CUMIN SEED
2 ½ TABLESPOONS CORIANDER SEEDS
1 ½ TABLESPOONS GREEN CARDAMOM PODS, CRUSHED
3 ½ TABLESPOONS GROUND TURMERIC

CHILE PEPPER

Shichi-Mi Tōgarashi

Also known as seven-spice pepper, this is used as a table condiment and sprinkled atop soups and other food in Japan.

Toast the following (except for ground ginger, if using), and coarsely grind together.

SZECHUAN PEPPER

POPPY SEED PODS

3 TEASPOONS CHILE FLAKES
3 TEASPOONS JAPANESE SANSHO PEPPER OR SZECHUAN PEPPERCORNS
1 TEASPOON DRIED SEAWEED
3 TEASPOONS DRIED TANGERINE PEEL
2 TEASPOONS WHITE SESAME SEEDS, TOASTED
1 TEASPOON BLACK SESAME SEEDS, TOASTED
1 TEASPOON POPPY OR HEMP SEEDS, TOASTED, OR SUBSTITUTE GROUND GINGER

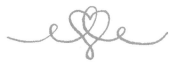

The Case for
HAND LETTERING

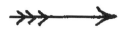

by Deborah van der Schaaf

Hand lettering isn't just a fun activity. Giving words a nice form emphasizes their meaning. Try adding style to your words in a few simple steps.

You don't have to be able to write beautifully to draw beautiful letters. You can learn how, either by following the method outlined here or using freehand—choose the technique that suits you. Once you have a few basics in your repertoire, seek out inspiration—Etsy, Instagram, and Pinterest, of course, have no shortage of lovely hand-drawn posters. My boyfriend's father was a sign painter; I'm lucky to be able to refer to some of his old textbooks. Collect menus, study old posters and newspapers, look closely at candy wrappers. And give yourself room to make mistakes. I think the ampersand is the most beautiful character: &. It has so many wonderful variations. But, to be honest, when I draw it from memory, I always get it wrong!

You will need:

PENCIL (2B) ← soft, easy to erase
ERASER
RULER
FINELINER ← thick and thin lines
< POSSIBLY: MARKER PEN >
< POSSIBLY: DIP PEN AND INK >
PLAIN PAPER
< POSSIBLY: GRAPH PAPER >
< LATER : FANCY PAPER >
(OLD) FONT BOOK (LIBRARY!) or
WEBSITES WITH EXAMPLES

HOW TO start

- Find pretty sample letters

- Sketch in pencil (light, erasable strokes)

- Draw 3 lines: baseline, x-height, and uppercase height

- Follow the directions at right

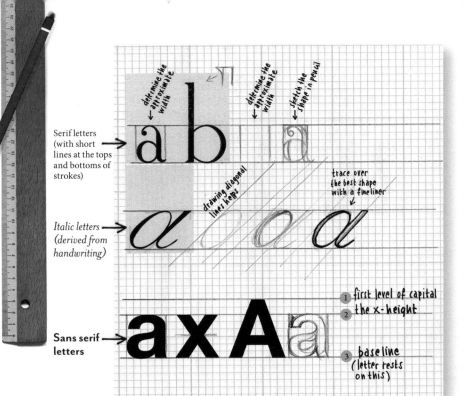

Serif letters (with short lines at the tops and bottoms of strokes)

determine the approximate width

determine the approximate width

Sketch the shape in pencil

drawing diagonal lines helps

trace over the best shape with a fineliner

Italic letters (derived from handwriting)

Sans serif letters

1. first level of capital
2. the x-height
3. baseline (letter rests on this)

Now you ↓

Now try it without graph paper... a

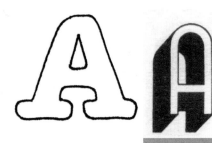 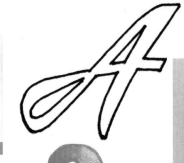

Use the letterforms above as an example. Draw them strictly (ruler) or loose (free hand). Vary: wider, narrower. You can also combine forms.

ICE CREAM CONE A

AN A WITH DASHES OR TRIANGLES

USE THESE OUTLINES TO MAKE A s

AN A WITH FLOWERS OR LEAVES

AN A WITH A SHADOW

Now you ↓

WHEN YOU'RE
Smiling

an interview with clinical psychologist Tara Kraft
by Renate van der Zee

Feeling stressed? Turn that frown upside down.
Even if your smile isn't quite genuine, you'll soon feel better.

HOW DID YOU GET THE IDEA TO STUDY SMILING?

How often do you hear people say that it's good to keep on smiling when things go wrong? There are all kinds of song lyrics like "keep smiling though your heart is breaking," and phrases like "grin and bear it." We were interested to see if there could be some truth in these old adages. From other research, we know that smiling has a positive impact on your mood.

We wanted to further explore the data to see what smiling can do for your body, and we decided to focus on the heartbeat. We know that stress is bad for your heart, so we explored if it might be good for your heart to keep smiling in stressful situations.

DID YOU LOOK AT POSSIBLE EFFECTS OF DIFFERENT KINDS OF SMILES?

Yes, because there is a clear difference between a genuine and a fake smile, and we use it ourselves daily in social exchanges. The fake smile activates only the muscle group in your cheeks. But a real smile activates the muscles around your eyes, too, so you get crow's feet or laugh lines. When you say you see a twinkle in someone's eyes, you actually mean you've noticed that the muscles around that person's eyes are working. We wanted to know if real or fake smiles would make a difference in your health.

HOW DID YOU EXAMINE THAT?

We asked the participants to hold chopsticks in their mouths. We instructed some of them to hold the chopsticks in such a way that they produced a genuine smile, with laugh lines. The second group was told to force a smile, and the third group had to keep their faces neutral. Half the participants knew what sort of research we were doing, but the rest didn't. We wanted to see if it would make a difference if participants were aware that they were smiling. We told the second half that we were studying multitasking and wanted to see how people react when they do a task with chopsticks in their mouths. The chopsticks were essential for our research, because they let us make people smile without their being aware that they were smiling.

Then we asked all the participants to complete a stressful task. First, we asked them to use their left hand to trace the contours of a star which they could only see reflected in a mirror. We promised them a reward if they managed to do it fast. It's really hard to do, and we could see our participants' heart rates shoot up.

The second stressful task involved holding a hand in a bucket of ice water for a whole minute. We know that cold activates the same areas in the brain as pain does, so it's really not a fun thing to do.

Throughout the trial, and for a short time afterward, we recorded participants' heart rates and blood

pressure. For us, the time after the trial was especially important. It's not bad for your health if your heart rate accelerates suddenly during a stressful event. What's important is that your heart rate goes back to normal quickly. People who take longer to recover run the risk of various health problems.

AND WHAT DID YOU FIND?

People who really smiled during the trial recovered the fastest, followed by people with fake smiles. The people with neutral expressions recovered the slowest. What we found most interesting was that it made no difference whether you knew you were smiling or not—the result was the same. Fake or real, a smile activates facial muscle groups and sends a positive message to the brain, which in turn allows the body to respond positively.

THAT'S AN AMAZING RESULT.

Indeed—we thought so, too. Smiling is so easy, and now it seems it truly has a positive effect on health. Other research suggests that smiling is contagious: If someone sees you smile, they will smile back. So your smile can stimulate good health in others, too.

We are investing so much money and energy into ways of curing and preventing heart disease. It's amazing to think that something as simple as smiling can

have a positive impact on improving your heart condition during a stressful experience.

WELL, OKAY, SMILING CAN'T REALLY PREVENT SERIOUS HEART DISEASE.

That's right, the effect isn't that great, of course not. But we did observe more than just the positive effect on heart rate, because we also kept track of how the participants felt during the trial. All reported that they felt less happy while performing the stressful tasks. But the smilers reported a much smaller dip than the people with neutral expressions, and they could handle the task more positively.

WHAT WAS THE RESPONSE TO YOUR STUDY?

We were pleasantly surprised by the favorable reactions. Many people believe that smiling has a certain positive force in most situations. But when that was not scientifically proven, it was easy to dismiss the believers as woolly thinkers. Those people think it's great that we now have scientific evidence for their belief in the power of smiles.

WHAT'S NEXT?

We now want to take our participants out of the lab, and get them smiling while they undergo stressful everyday situations—for instance, when they have to drive in traffic or get a shot. It will be interesting to see if smiling in those circumstances has an equally strong effect on their heart rates.

DO YOU SMILE MORE OFTEN NOW?

Absolutely. One of the most stressful tasks for me is answering all the emails that land in my in-box. Usually I do it at the end of the day and I'm often in a hurry. I can get pretty stressed. I'm now in the habit of holding a pen in my mouth, like my participants did with their chopsticks. My students are always in stitches when they see me like this. Which, of course, is very good for their health, too.

LOOK AROUND YOU

You pass the same places day after day: on your way to work, going to the supermarket, or walking to the coffee shop and back again. Next time you go out, take a really good look around you. Chances are you'll see things you wouldn't normally notice. Let this visual checklist inspire you.

☐ THE NUMBER 11

☐ A BENCH

☐ CLOUDS

☐ A TRAFFIC LIGHT

☐ A DAISY

☐ A SNAIL

☐ A PLAYGROUND

☐ A SPARROW

☐ A FEATHER

☐ A FALLING LEAF

☐ A BIG OLD TREE

☐ A RAIN PUDDLE

☐ A GREEN DOOR

☐ A CAT IN
A WINDOW

☐ A STICKER ON A
LAMPPOST

☐ PEOPLE SITTING
ON A BENCH

☐ A CROSSWALK

☐ A ROBIN

 ☐ A PLAYING CHILD

 ☐ A CANDY WRAPPER

 ☐ A BICYCLE

 ☐ WILDFLOWERS

 ☐ A FROG

 ☐ A DANDELION

 ☐ A GARBAGE CAN

 ☐ STREAMING SUNLIGHT

 ☐ SOMEONE WEARING HEADPHONES

 ☐ YOUR DREAM HOUSE

 ☐ A STAINED-GLASS WINDOW

 ☐ RAINDROPS ON A WINDOW

 ☐ A STREET MUSICIAN

 ☐ IVY

 ☐ SIDEWALK CHALK ART

 ☐ A LATTE

 ☐ AN OLD-FASHIONED BELL

 ☐ A SPIDER IN A WEB

 ☐ A RED CAR

 ☐ A LITTLE DOG

 ☐ A DOOR KNOCKER

 ☐ A POND WITH WATER LILIES

 ☐ A WINDOW WITH LACY CURTAINS

 ☐ A BABY CARRIAGE

You mustn't wish for another life.
You mustn't want to be somebody
else. What you must do is this:
"Rejoice evermore. Pray without
ceasing. In every thing give thanks."
I am not all the way capable
of so much, but those are the
right instructions.

Wendell Berry
Excerpted from *Hannah Coulter*
(Counterpoint, 2004)

What's the Line of Your Life?

Making a Time Line

by Fleur Baxmeier
illustrated by Ruby Taylor

On the next spread there is a removable time line with tips on how to fill it in. →

A personal time line is something that can be really helpful when making choices and plans for the future. It literally lets you look back in time and consider: I've done all this; this choice led to good things; or this is a feeling I want to have again.

Career coach Esther Esselbrugge explains how to create a forward-looking time line: "Start with your birth, and from that point on think of ten to twenty moments, big and small, that you experienced as important, fun, or successful. It could be a party you organized for work; a workshop you attended; it could be the moment you started your own company." According to Esselbrugge, this thinking process sets all kinds of little wheels turning in your mind, improves your self-confidence, and gets your creativity flowing.

BRAINSTORM

A mini-brainstorm can help to line up the events, moments, and time periods that were important to you. What were the best times, sad moments, or inspirational encounters? Think of your family and environment in your early childhood: the times you moved, maybe the divorce of your parents, an

inspiring teacher, the death of someone close to you, music lessons, sports, something else you are passionate about. Which friendships and loves had a great impact on you? And what did your student years or your first work experience mean to you? What effect do your children, if you have any, have on your life?

What do you want to change? By brainstorming and then organizing your thoughts, you can discover where you are in life. When did you feel truly happy, and when did things not turn out exactly as you planned?

COMMON THREAD

Once you've written down your ten to twenty moments, try to find the common thread that's running through them. Which activities or events recur? "In your mind, or with scraps of paper, label each event," Esselbrugge advises. "What talent did you use at this moment? What part of your personality was expressed?

What made it fun? Now use those labels to think of what would be fun to experience in the future. What have you always dreamed about accomplishing? Or, try focusing on the moment when you expect to retire. Imagine everything is taken care of, with no more obligations or work. What do you want to do? Are there any experiences that you'd like to try again, now that you've grown and learned more about yourself along the way?

ORGANIZE

Collect and cut out the years and symbols (see the removable fourth panel in the foldout for some inspiration) that represent your important moments, and glue or write them on your time line to create your own life story. You can also draw stuff on the time line, glue on your own pictures, or write more things.

DISCOVER

When you're done, take a step back. Hang it on the wall. Look at your time line to see patterns, discover interesting developments, or recognize pitfalls.

INTO THE FUTURE

"Now, go back to today on your time line and use this knowledge to look toward the future. How can you create more of those fun moments in the coming years? And what little plans can you start on today?

"You'll see that, when you look at everything you've already achieved, it removes the obstacles that often loom when thinking about undertaking new things," says Esselbrugge. "You use the past to predict the future in your mind. And that's not only a really nice way to find out what you want to do in life, it also helps you actually do something about it."

Don't Be Afraid of
Emotions

by Otje van der Lelij

We often hide our emotions or try to escape from them by keeping ourselves busy. But emotions actually provide us with useful messages about ourselves, letting us know who we are and what we value.

I'm someone who prefers to walk away from sadness. If I feel bad, I play the piano, get absorbed in work, fret over inanities, or drink wine with a friend. I distract myself, numb my feelings, or flee into my thoughts—anything to avoid facing any kind of bad feelings.

Then, when I can no longer flee, at a funeral for example, all the emotions come rushing out. No matter how hard I concentrate on the wood grain in the bench before me, or on the colors of the stained glass, my pent-up sadness finds a way out. I only need to see the pain in someone else's eyes to break down. I'll cry harder than anyone else, even if I didn't know the deceased that well. Sometimes—and this happened especially when I was younger—my crying turns, uncontrollably, into laughter.

FROM UNINHIBITED TO STIFLED

Mindfulness therapist Rob Brandsma says I am not alone. "We like to be in charge and prefer to choose what we feel and when," he says. "But emotions don't care about our wishes. They do exactly what they need to do. So sometimes they just pop up and take over our body and our thoughts."

As he explains, the ability to control our emotions has had an important evolutionary role in our survival as a species. "Thanks to emotions, our early ancestors were able to quickly take action when it mattered," he says. "They could fight or defend themselves; make love or keep the group together. Fear, anger, jealousy, sadness—all of these emotions would inform our actions, and still do."

What often scares us is not just the intensity of our emotions but also the sense of vulnerability that comes with them. When we express our emotions, other people get a glimpse of our deeply personal experiences. We don't always feel comfortable with that, so we push emotions as far away as we can. We are especially reluctant to feel anger and sadness, research shows. But even positive feelings such as pride and exuberance are often quashed, for fear of appearing arrogant on the one hand or childish on the other.

The roots of these fears go back to our childhood, explains psychotherapist Rogier Poels. "If our parents felt uncomfortable about certain emotions or if they responded disapprovingly to our emotions, no matter how subtle it was, we would pick up on those signals," he says. "So early in life, we learned which emotions were welcome and what behavior was undesirable."

Parents who tell their children that all emotions are okay but who never express certain emotions themselves, such as sadness for example, also transmit the message that certain emotional states are somehow unacceptable, he says. They're implicitly passing on the message that it's better to keep certain emotions under wraps. When those emotions surface, they can frighten us. We slowly change from uninhibited, free children into grown-ups who are stifling our emotions, fighting our feelings.

I can relate. My parents didn't disapprove if I cried or got angry, but I could tell that my emotions affected them. If I was sad, my parents would often be sad, too. And when I got angry, they were sometimes alarmed by the intensity of my reactions. I didn't want to burden them, so I learned to hide certain emotions.

The people around me preferred to see me laughing, smiling, enthusiastic, and radiant, so I let those emotions show. Any really painful emotions were pushed far away, because if I were to let them out, everyone would think something terrible was happening and that wasn't the case. So it was better to show only my "acceptable" emotions. And as a consequence, to this day, all my sadness and anger can just accumulate and then sometimes—when the dam breaks—they come bursting out at full force.

KEEP RUNNING

Emotional avoidance can be achieved in various ways. We drink alcohol, we eat more—or less—than usual, play sports, watch TV, or indulge in "retail therapy." We push away our sad thoughts and hide our true emotions behind a false smile. Even feelings can be a way of not feeling. We can flee into anger when we

are actually feeling sad. Sometimes we have become so adept at smothering any trace of a particular feeling that we don't even notice when we have feelings.

"Take the expression 'keeping busy,'" says Brandsma. "People who've been through something traumatic and meet a friend often answer the question about how they're doing by saying, 'Oh, keeping busy.' It almost seems like a legitimate way to get over something. You don't sit down to feel the full force of the emotions, but keep running so you don't have to pay attention to your feelings."

That's not so terrible, of course. It can even be a great temporary coping mechanism, Brandsma says. In fact, it can be very good to put your emotions on a shelf for a bit and distract yourself. But when this becomes an automatic thing for you, you end up further and further away from your true state of mind. Because when your vulnerable side knocks on the door, you run for the hills.

Emotions teach us important things about ourselves. "They tell you something about your needs, and they communicate what's going on inside you," says Poels. "Anger means you were hurt, or that someone crossed a line; love is a sign that someone is important to you; fear wants to protect you from danger; happiness is telling you that all is going well and your wishes have been granted."

In short, emotions are intensely personal messages that tell you who you are and what is important to you. And they always have your best interests in mind. It's interesting to approach them with curiosity: *Oh, hello, what are you trying to tell me?*

JUST SIT AND OBSERVE

"Feelings want to be heard, so they will keep trying to draw our attention to them," says Brandsma. "No matter how good you are at running, your emotions will always keep trying to seep into your consciousness. You become somber or grumpy, or you feel uncomfortable. You can feel it most at the end of the day, when your reservoir of distractions is drying up. What it boils down to is that you have to be busy all the time, or else emotions will be able to grab you."

What's more, all that suppression drains your

The first step is simple enough: Stop and let your feelings in. Luckily, this is less scary than you might think.

energy and has all of the usual consequences, like fatigue, headache, and physical tension. It can also influence your ability to feel positive feelings. "The walls we build around ourselves to keep sadness out also keep out the joy," wrote author and motivational speaker Jim Rohn.

The first step is simple enough: Stop and let your feelings in. Luckily, this is less scary than you might think. "What people generally dislike most is that when an undesirable emotion pops up, it is paired with the fear for that emotion," says Poels. "Just purely feeling the anger or the unadorned sadness may be unpleasant, but that's not what people are scared of. Once my clients have achieved contact with their feelings, they usually feel relieved. People are also scared that they won't be able to stop feeling once they start; they're scared they will drown in their emotions. But emotions run their course like waves in the ocean. They start off small, grow larger to their breaking point, and then crash and fade away. This is almost always followed by a sense of lightness, space, and relaxation."

Poels says that rather than pushing our emotions away, we should be seeking them out.

A tried-and-true way of doing this is by practicing mindfulness. "I like to think of mindfulness as 'rich observation,'" says Brandsma. "Everything that happens in the moment, including experiencing emotions that you might find scary, is okay. You look upon it all

mildly and without judging; there is nothing bad about what you're feeling. This way you learn to be with your emotions and, therefore, you learn to be with yourself, too."

This is, in itself, a beautiful goal because you won't have to use up so much energy trying to push things away. Just sit in a chair, says Poel, and quietly scan your body for feelings. "What does your body feel like? Where is the tension? What kind of feelings are coming up? And where are you feeling these emotions?"

Recognizing these physical signals is key, says Poels. "If, for example, you notice that your jaw is very tense when you are angry, then you learn to recognize your anger sooner, because you notice, 'My jaw's feeling tense, maybe I'm angry?'"

After learning all this, I've recently been trying to stop pushing away my moments of sadness. I still find it difficult to admit my anger or sadness, especially when I'm in the company of other people, but I recognize it now. Sometimes I take a moment and sit down. If the children are in bed, I meditate or just sit on the couch. Any emotions I have will then surface. If I put the wall up and try to suppress my emotions, they build up and become more intense, waiting for some release—like the next funeral. But if I keep the wall down, my emotions, like water against a dam, can simply spill across into the lake, and I can just be there with them, in the moment.

HOW ABOUT YOU?

Sit quietly in a chair for a while and scan your body for feelings,
then answer these questions:

1. **Do you sense any tension anywhere?**

2. **What kinds of feelings are emerging?**

3. **Where do you feel these emotions?**

4. **What could these emotions be telling you?**

CHAPTER 3

TIME TO CREATE

Creating and writing are such good ways to clear the mind, and one of the best parts about making *Flow* magazine is how connected we are with other creative people worldwide. People who, just like us, love paper, illustrations, and being creative—they make it such a joy to open our mail. (Sometimes, we get jealous. There are so many people making and writing such beautiful and compelling pieces of art, and we are so often disappointed when we see the results of our own creative afternoons!)

But then we read somewhere: It is not about the result, it is about the process. Of course that is so true. When did we start becoming dissatisfied with the results? When you enjoy doing something, what does it matter whether you are good at it? Isn't that how we did it in our childhood? Back then we just started, without any expectations about the outcome or the result. And we had the most epic afternoons, spending hours sticking paper onto newspaper to make collages, drawing things that were unidentifiable, and writing nonsense in a diary. But we were happy. And that's the feeling we cherish, even—or *especially*—if it is hard to do so as an adult.

Slow Soup

by Aran Goyoaga

Rich and flavorful soups with lots and lots of vegetables,
like a grandmother in the Basque Country would make,
will fill your kitchen and home with the scents of comfort.

RAMPS SOUP WITH POACHED EGGS

SERVES 4

1 quart vegetable stock
¼ cup olive oil
6 ounces ramps, washed and thinly sliced (separate the white stems from the green leaves)
1 tablespoon Spanish paprika
1 slice of dry bread, crumbled (you could toast it slightly)
Salt
4 eggs

Heat the stock in a medium saucepan over medium heat. (Keep it at a low temperature so it's warm when you are ready to add it to the soup.) Heat a cast-iron pot over medium-high heat. Add the olive oil and the ramp stems. Cook for 1 to 2 minutes until translucent, but do not brown. Add the paprika and the bread and stir until all flavors are incorporated. Add the stock and bring the liquid to a simmer. Cover the pot and cook for 15 to 20 minutes. Add the ramp leaves; stir and cook for another 3 minutes. Taste and add seasoning if needed (it depends on how salty your stock is).

Ladle a serving of soup into a small saucepan. Heat over medium heat until the soup is simmering. Crack one egg into the soup and let it slowly cook in the broth for 2 to 3 minutes until the white is set but yolk is still runny. Repeat with the other 3 eggs and the rest of the soup. Add a pinch of salt and serve.

NOTE: Ramps, or wild onions, can be very dirty, so make sure you wash them well. They have a very slimy film around them. Pull that off, cut away the root tops, and wash well under cold water. This is a very simple soup, and a lot of the flavor is in the stock, so make sure it's really good, whether homemade or store-bought.

Ramps Soup with Poached Eggs

Avocado and Apple Soup
with Poached Salmon

AVOCADO AND APPLE SOUP WITH POACHED SALMON

SERVES 4

8-ounce salmon fillet

Salt and black pepper

¼ cup olive oil

2 ripe avocados, peeled, pitted, and diced

1 medium green apple, peeled, cored, and diced

1 medium cucumber, peeled, seeded, and diced

½ medium onion, diced

2½ cups stock

¼ cup thinly sliced radishes

¼ cup sliced green onions

Watercress leaves

Season the salmon with salt and pepper. In a small saute pan, heat the olive oil over medium heat until warm. Add the salmon and let it cook slowly for 5 to 7 minutes until the outside is no longer opaque but the center is still slightly pink. Meanwhile, puree the avocados, apple, cucumber, onion, stock, ½ teaspoon salt, and ¼ teaspoon pepper in a blender. (It will be thick—add more stock if desired.) Taste and add more seasoning if necessary. Serve the soup at room temperature topped with the flaked salmon, radishes, green onions, and some watercress leaves.

CELERY ROOT, FENNEL, AND SWEET POTATO SOUP

SERVES 4 TO 6

2 tablespoons olive oil

½ medium onion, diced

2 garlic cloves, minced

½ medium fennel bulb, diced

2 medium celery roots, peeled and diced

2 sweet potatoes, peeled and diced

Celery Root, Fennel, and Sweet Potato Soup

1 russet potato, peeled and diced

3 sprigs of thyme

1 quart stock

Salt and pepper

Parsley pesto (try your local farmers' market)

In a large soup pot, heat the olive oil over medium heat. Add the onion, garlic, and fennel. Stir and cook for 5 minutes. Add the celery roots, sweet potatoes, russet potato, thyme, and stock. Bring the liquid to a boil over medium-high heat, then reduce it to medium-low, cover the pot, and cook until the vegetables are tender, 15 minutes. Puree in a blender. Add water if it is too thick. Season with salt and pepper to taste. Serve the soup with a swirl of parsley pesto.

Meditation
Makes You More Creative

An interview with psychologist Ayca Szapora
by Renate van der Zee

Meditation not only reduces stress,
it also makes your brain work in more creative ways.
Even a session as short as thirty minutes can do the trick—
but you have to do the right kind of meditation.

SO IF I MEDITATE FOR HALF AN HOUR BEFORE A BRAINSTORMING SESSION, WILL I COME UP WITH BETTER IDEAS?

Yes, but it depends on which meditation technique you use. There are so many different kinds of meditation, and they don't all increase creativity.

ISN'T MEDITATION ALWAYS GOOD FOR YOUR MIND?

Yes, you hear that quite often. But studies have resulted in very different outcomes. While some studies show that meditation has a very favorable effect on creative thinking, others indicate that it has no effect at all. We found this very confusing until we discovered that these researchers had studied different types of meditation. That's when we decided that it was high time to carry out some clearly defined research on the matter.

ARE TYPES OF MEDITATION REALLY ALL THAT DIFFERENT?

Yes. There is "focused attention" meditation. This is where people focus on one specific thought, or one object, or one activity—such as their breathing. Every time their attention wanders, they direct their thoughts back to that object or activity. But there are other forms of meditation where people open up their minds to everything that's going on, which we call "open monitoring" meditation. It's the opposite of focused meditation, because you open yourself up to observing everything that is happening in your mind and body. We anticipated that different forms of meditation would create different states of mind and that they would, in turn, have different effects on your creative thought processes. It turns out we were right.

WHAT MIND-SET BEST ENABLES CREATIVITY?

When you're very focused, you can read and write very well. But if you want to brainstorm, you should actually focus less. You need to be able to make quick connections, build webs of thought, and to jump from idea to idea. We call this divergent thinking. A good example is how you think when you want to buy a gift for a friend. There is no one fixed answer: You can buy them something (like a book or a perfume) or take

them out or fulfill a wish they expressed during a recent conversation (like a dinner or a bicycle or hot air balloon ride). That's the kind of thinking you need in order to be creative. The big question in our research was: What type of meditation stimulates this?

HOW DID YOU STUDY THIS QUESTION?

We found nineteen participants for our study who were experienced in meditation. We invited them to our lab three times and asked them to do a different task each time, under the supervision of a meditation coach. Each participant did a focused meditation, an open meditation, and a visualization. Each exercise took twenty-five minutes. Then we checked whether the subjects were thinking more creatively than before the meditation session.

HOW DID YOU CHECK THAT?

We asked them to think of things they could do with a normal everyday object, like a shoe, and write down anything they could think of within a set period of time. They were given scores for this in various areas: for the number of things they thought of, but also for the variety of their ideas. If someone wrote, "You can use a shoe to play soccer, to run, to dance, and to play basketball," we considered that to be one category, "using as a shoe." The more categories people thought of, the higher we rated them for creative thinking.

AND WHAT WERE THE FINDINGS?

When our participants did an open meditation exercise, they thought of far more things to do with an everyday object than when they preceded their brainstorm with focused meditation or visualization. The difference was significant in both instances. For us, it meant we could draw the conclusion that that particular form of meditation had drawn them into a more creative state of mind.

DID YOU EXPECT THESE RESULTS?

Yes, we did, but it was still very satisfying to be able to attach scientific evidence of the different effects of different forms of meditation on creativity to our initial hypothesis.

WHAT HAS THE RESPONSE BEEN TO YOUR RESEARCH?

We've been quite surprised by the response. It was remarkable. We got lots of reactions; my supervisor had never experienced anything like it before. The news about our research and the link to our site have been shared worldwide via international news sites millions of times.

HOW DO YOU EXPLAIN ALL OF THE INTEREST?

Creativity is essential for many people—from scientists to artists, from spiritual leaders to businesspeople. Anyone who needs to problem-solve relies on creativity. So of course the fact that it can be improved by something as simple as meditating for under half an hour is intriguing.

WHAT WOULD YOU RECOMMEND TO ANYONE GETTING READY TO BRAINSTORM?

First, sit down and practice open meditation for half an hour. People who have never meditated before can also take that first step without much trouble. And it will still have a positive effect on your creativity. You can start with a simple exercise: Lie on your back, shut your eyes, put one hand on your chest and one hand on your belly. For five minutes just observe your breathing. Don't change anything; just feel what happens in the moment. Try to allow the sensations in your body to simply occur. You can also do this sitting down, just before the brainstorming session, whether you're by yourself or with others. This already brings you into an altered state of mind, and that's a good thing.

DO YOU PRACTICE THIS FORM OF MEDITATION?

Yes, I do a certain type of breathing exercise called breathfulness. I do this to relax and to return to my body in times of stress. I'm so impressed by it that I've just completed a training course to become a coach in this technique. Colleagues who are preparing for a job interview or some other important event now often come to me to do a session to reach that positive state of mind.

IT SEEMS LIKE YOU HAVE REALLY MADE AN IMPORTANT DISCOVERY.

Now that I'm telling you about it, I feel the excitement all over again. For me this is not just work; I share it with my friends and everyone I know, because it really works. And the steps you have to take are so simple. Of course, you can go on an extensive meditation retreat if you want, but our research now demonstrates that you can also achieve substantial improvement of your creative thinking with a very small exercise. I find that fascinating.

Earth, Fire, and Water

We can make our minds so
like still water that beings
gather about us,
that they may see,
it may be, their own images,
and so live for a moment
with a clearer, perhaps even
with a fiercer life because
of our quiet.

W. B. Yeats
The Celtic Twilight: Faerie and Folklore

SNAIL MAIL

No matter how quick and efficient it is to send
a text message, nothing is better than a handwritten card.
By taking time out of your day to write and mail it,
you tell the recipient that your relationship is one you care about,
and it creates a lovely surprise amidst all the junk mail.

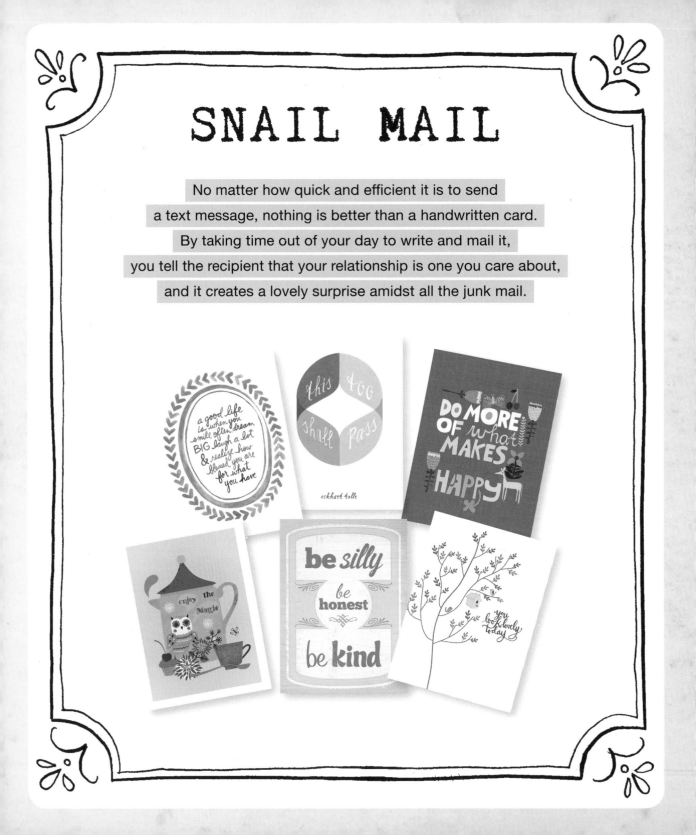

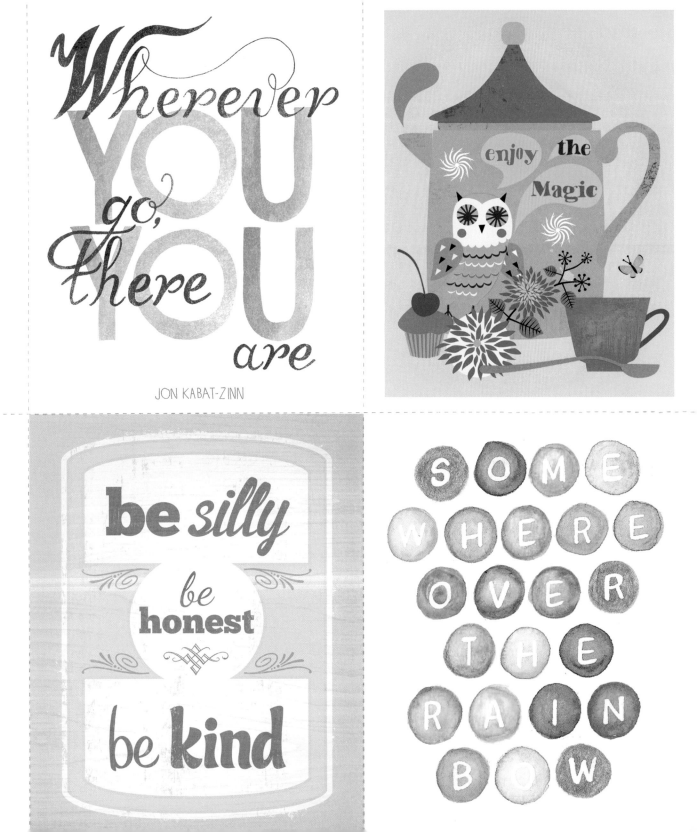

workman

flow

ELISANDRA

workman

flow

DEBORAH VAN DER SCHAAF

workman

flow

NICOLE MIYUKI SANTO

workman

flow

WICKED PAPER

this too shall pass

eckhart tolle

DO MORE OF what MAKES you HAPPY

you look lovely today

Being somewhere is more important than getting somewhere

Michael Carroll

workman

flow

CAROLYN GAVIN

workman

flow

DEBORAH VAN DER SCHAAF

workman

flow

DEBORAH VAN DER SCHAAF

workman

flow

RIGA SUTHERLAND

Thoughts aren't FACTS so don't take them SERIOUSLY

RUBY WAX

Did you spot any of these today?

LOVE ME

LAUGHTER is THE SUN THAT DRIVES WINTER FROM THE HUMAN FACE

VICTOR HUGO

Celebrate THE LITTLE THINGS

workman flow FLOW MAGAZINE/SHUTTERSTOCK

workman flow DEBORAH VAN DER SCHAAF

workman flow OH SO PRETTY PARTY

workman flow CAROLYN GAVIN

a good life
is when you
smile often, dream
BIG laugh a lot
& realize how
blessed you are
for what
you have

Creativity
takes
Courage
Matisse

It ALWAYS
SEEMS
Impossible
until it's
DONE

DO YOU
DO
WHAT
feels
GOOD?

workman

flow

CAROLYN GAVIN

workman

flow

NICOLE MIYUKI SANTO

workman

flow

MARLOES DE VRIES

workman

flow

DEBORAH VAN DER SCHAAF

Lists Clear the Mind

illustrated by Eva Juliet

Taking the time to write lists makes it easier
to visualize how to make changes
and cultivate gratitude for all the good in your life.

Things that make me happy

Things that worry me

Habits I want to break

Things I want to let go of

Things my inner critic tells me
(and what I want to say back)

—

Things that give me energy

How to be *HAPPY* with yourself!

BY OTJE VAN DER LELIJ

TREAT YOURSELF THE WAY YOU WOULD TREAT A GOOD FRIEND. WOULD YOU BE SO HARD ON HER IF SHE ALSO HAD A BAD DAY?

DO YOU GIVE YOURSELF A HARD TIME? EVERYONE HAS AN INNER CRITIC; THE QUESTION IS, SHOULD YOU LISTEN TO IT?

LOOK IN THE MIRROR AND GIVE YOURSELF A HEARTFELT COMPLIMENT.

STOP COMPARING YOURSELF TO OTHERS. AND IF YOU REALLY CAN'T, LET IT INSPIRE YOU INSTEAD.

GET ENOUGH SLEEP, EAT HEALTHFULLY, AND SPEND TIME WITH PEOPLE YOU LIKE. CARING FOR YOURSELF GOES HAND IN HAND WITH SELF-ESTEEM.

ACCEPT AND ENJOY THE COMPLIMENTS YOU RECEIVE, AND VOICE YOUR SINCERE APPRECIATION OF OTHERS.

FAKE IT UNTIL YOU BECOME IT: SIT UP STRAIGHT, PUT YOUR SHOULDERS BACK, AND LAUGH WITH YOUR WHOLE FACE. A CONFIDENT DEMEANOR PORTRAYS SELF-CONFIDENCE, EVEN IF YOU'RE NOT FEELING IT AT THE TIME.

DON'T DEFINE YOURSELF BY YOUR FEELINGS: YOU ARE NOT YOUR FEELINGS; YOU MERELY HAVE THEM.

ILLUSTRATED BY RUBY TAYLOR

Take Just One Photo

by Sjoukje van de Kolk

With digital cameras, everyone has the potential to become a documentarian these days. We take thousands of photos— bad and good—and never delete anything. How about just taking a single shot?

I have only one photograph of my grandmother. It's one of those posed pictures, where she's looking into the lens and wearing her Sunday best. It stands in a place of pride on my mantelpiece.

My grandchildren probably won't do that. There are hundreds of photos of me—and thousands of my children. In the days of film, it was rare that I had time to go through all the images, order prints of the ones I liked, and then arrange them all in a photo album— but since I've had children and digital photography replaced film, I simply can't keep up.

Els Jacobs, a cultural anthropologist and professional organizer, thinks that our need to take—and keep—a million photos relates to a primeval urge. When we were hunters and gatherers, she says, we had to hoard food and tools, because we never knew when we'd come across them again. Now that drive has transferred to photos.

"Biologically speaking, we're miles behind the technological advances of our time," Jacobs says. "That collecting and hoarding urge is in our genes, and you see it reflected in all human cultures."

BEYOND BIRTHDAYS

Better technology ensures that we have to deal not only with large quantities but huge increases in speed, too. When you only had one roll of twenty-four or thirty-six photos, you carefully considered which shots to take. Developing the film took time and cost money, so you had to wait for the prints or head into the darkroom yourself. Now, with the push of a button, you can take seven pictures at once, at no cost. We used to record highlights; now we record everything.

"I once searched for photos of housework taken between 1900 and 1960 for a project," says Jacobs. "They're very hard to find. Back then, you took photos on birthdays, the first day of school, graduations, or for a family portrait every few years. The challenge now is to take photos of life as it really is. We don't want to forget anything, so we record everything.

"This is especially true with our kids. Everything they do seems to be important and unique, so we try to capture it all. We don't want one photo of our daughter blowing out the candles on her cake. No, we snap thirty shots from all angles."

The key question is:
What quality of life do
I choose—the picture
or the experience?

Jacobs thinks this has to do with the fact that families today are having fewer children than they had in the past. "That single child you have, or the two, they are so special that you don't want to miss anything about them," she says.

TELL YOUR OWN STORY

But ultimately, are we happy with all those photos? Not really. Because although it's fun to take pictures, once they are there, they pull on your mind: *Oh no, I haven't gone through the last download yet*, or *I really should make a digital album*, or *Let me sort them*. But you never get around to it.

When it comes to our children, Jacobs recommends giving your children one album—not fifteen, and not a USB drive with a thousand pictures on it as a memento of their childhood.

"It's the limitation that ensures the album is special," she explains. She has a book of her childhood that is almost falling apart and has only the highlights, totally missing some years. "And that's a good thing," she says. "If your album can breathe, if it has gaps, then there's space for your own thoughts and feelings when looking through it. And if you want to know more, you can ask your brothers, sisters, aunts, or your old neighbor. The nice thing about an album with gaps is that it lets stories be told."

PARTICIPATE IN THE PRESENT

Mindfulness trainer Wibo Koole mentions another good reason to take fewer photos: If you are constantly shooting, he says, you actually forget to engage.

"Often we're so busy taking pictures that we forget to enjoy the here and now, and miss the scent, the flavor of the environment," he says. "Taking pictures is fun, but it's more fun to look around and experience what you see. That gives quality to life. The key question is: What quality of life do I choose—the picture or the experience?"

Jacobs feels it's good to try to figure out what a picture really means to you. Ultimately, it should be about the memory. Pictures fulfill our desire to look at the past, to muse about what has been, and to think about our history.

"A photo is a symbol," she says. "In the past, people used other symbols, such as the necklace that belonged to your great-grandmother. I find that photos have a good function in our lives. But they lose their power when you have too many. Life goes on and all these photos are just snapshots of moments, most of which are no longer relevant. So you can do with just a few meaningful photos and delete the rest."

BEAUTY WILL TURN UP AGAIN

We find this last bit—deleting photos—very hard to do. Compare it to all those beautiful drawings by your kids. "My mother used to put them sight unseen into the trash, but nowadays people find it hard to throw them away," says Jacobs. "Again, it conveys the idea that my child is special and everything he does is special. And so people save thirty drawings a year. Do the math: How many drawings will there be after fourteen years in school?"

Sometimes, says Koole, we try as hard as we can to hold on to and record out of fear of losing the moment. But life goes on. "The good thing is that more beautiful moments will turn up again," he says.

Conscious experiences make conscious memories, and each moment has its value—just as it is, without you recording it—and *that* makes you happy.

How Do You Make a Collage?
Open Your Mind Onto Paper

by Eva Loesberg

Making a collage is a great way to get a fresh perspective.
Forget about your to-do lists and your schedule for a moment.
Then tear, cut, paste, and create, using your intuition as a guide.

"All you need are scissors, glue, a sheet of paper or cardboard, and a stack of old magazines," says Ellen Vesters, an illustrator who gives collage lessons. "Anyone can make a collage. When you draw, you often have a picture in your mind, but with a collage you're led by what you find. Some people find this difficult, and that's exactly why I give this workshop: to show what happens when you let your hands lead the way."

First, workshop participants tear out pictures from magazines that speak to them, and then they search for a theme. It may be one image, or lots of different pictures of birds, or whatever they're feeling that day. Then they look at what pictures go together, and how to create an interesting composition. "I see beautiful things emerge," says Vesters.

HAPPY AND BUBBLY

You'd never guess it, but all that tearing, arranging, and gluing can teach you a lot about yourself and what makes you happy. Career coach Marlys Stradmeijer often asks her clients to make a collage. "While you're busy with your hands, you get into a flow. You don't think about what you're doing, but pick the pictures intuitively."

Stradmeijer buys extra-large sheets of paper, the kind that are just begging to be filled. "I tell them: Leaf through these magazines and cut out everything that appeals to you," explains Stradmeijer. "Cut out pictures or inspirational words, anything that makes you feel happy and bubbly when you see it. When you feel like you've collected enough, glue everything onto the sheet of paper without thinking about it."

When Stradmeijer looks at the result from a coach's perspective, there's more structure to the collage than you would expect. "For example, I sometimes see that nature is playing a big part," she says. "Or I can tell that there are very few people in the pictures. Or sometimes there are lots of people. Participants discover things, too. And when you discover the things that make you happy, you can ask yourself 'How much am I letting this be part of my life?' and 'What could I do to bring these things that make me happy closer to me?'"

When you try this at home, remember that "anything goes," says Stradmeijer. "When you're done, look at it with a friend. What do they notice about it?"

UNCONSCIOUS KNOWING

Making a collage can allow desires to surface that you weren't even aware of. "If I ask someone the direct question 'What do you love?' I never get the same answer as the one I see in their collage," says Stradmeijer. "In conversation, we're often held back by our own inner critic. But when you are in your creative flow, you're tapping into your unconscious."

In his book *The Smart Unconscious*, Dr. Ap Dijksterhuis, professor of psychology at Radboud University Nijmegen in the Netherlands, provides scientific evidence that most of our thinking and doing is determined without our conscious awareness. German scientist Gustav Theodor Fechner already gave us the iceberg metaphor: We only see the tip sticking out above the water—conscious thinking—and people believe this rules everything we do and think. But the subconscious is the other 90 percent of the iceberg that is hidden from even our own view.

The unconscious is also more creative and more likely to come up with unconventional solutions. "The trick is to find the key to unconscious knowing, to this unconscious creativity," says Stradmeijer.

ENTIRELY NEW DESIGN

There's a good reason that interior designers and makeup artists, art directors, and other creative professionals often use collages—also known as mood boards—to get away from rational thinking patterns. For instance, mood boards serve as "an inspirational jumping-off point" for interior designer, author, and blogger Holly Becker, whether she's redesigning a room in her home, working with a client, or planning content for one of her books.

"Mood boarding helps you take everything out of your head and put it in front of you so you can see if all you've imagined really works or not," says Becker. "Sometimes what we see in our mind isn't going to translate into reality in the same way.

"I like storytelling, and each item contributes to what I'm trying to say visually: a ribbon, clippings from a magazine, a piece of wallpaper, some fabric, Pantone cards, and so on," says Becker. "When combined, they all build the room, from the color palette to the texture, pattern, materials, and the overall mood or vibe. I like the art of building something by adding in, editing, adding more in, editing again, until you have the perfect harmony before you and then your direction is very clear."

BOOKS TO INSPIRE

* *Decorate with Flowers: Creative Arrangements, Styling Inspiration, Container Projects* by Holly Becker and Leslie Shewring (Chronicle Books, 2014)

* *Paper Made! 101 Exceptional Projects to Make Out of Everyday Paper* by Kayte Terry (Workman, 2012)

* *Paper to Petal: 75 Whimsical Paper Flowers to Craft by Hand* by Rebecca Thuss and Patrick Farrell (Potter Craft, 2013)

CUTTING
&
PASTING

Are you in the mood to make your own collage? The following pages are full of different pictures and words to get you started. Just cut out whatever images or words appeal to you intuitively, then arrange them into categories or themes (such as, "I simply love this," or "I am looking for this," or whatever you feel). You can glue the clippings onto the fold-out here and then hang it up to inspire you.

TIME TO REFLECT

It's such a pity that, in life, we often fall into the trap of wanting more, or bigger, or better. It puts so much pressure on us. Somehow, in the last few decades, society has got us all thinking that if we could make our lives perfect, we would live that storybook happily-ever-after. That "truth" breeds an unhealthy drive that makes us break our backs to earn more money so we can purchase that bigger house, afford more extravagant vacations, and buy everything new—just because.

But eventually, we'll have to admit that living by that model, the "ever after" isn't necessarily a happy one. Life shouldn't be about more, bigger, and better. It should include stopping to think, breathe, and celebrate. When you take that time, you see the tiny pleasures in life, you see what they bring you: They add glow and depth to our lives, and wonderful memories for the future. So stop rushing. Stop blazing through life, perpetually distracted. Just stop. Now breathe.

Why Life Looks Better with a
Beginner's Mind

by Otje van der Lelij

Because of everything we know and all the opinions we've already formed about what we know, we are seldom able to just *look* at something. But how much better would it be if you could, every now and then, see everything with fresh eyes?

In a well-known parable from Zen Buddhism, a professor goes on a long solitary journey to visit a Zen master. He climbs mountains and finally reaches the home of the master, exhausted but full of questions. He sits down and starts talking—about his journey, his knowledge of Zen, and his own life. Then, he bombards the Zen master with questions—about Eastern philosophy, meditation, and religion.

The master listens silently and says, "You look tired, and you've come a long way to find me. Let me first make you a cup of tea." While the professor waits, he thinks of many more questions. As soon as the master returns with the tea, he starts talking again. Meanwhile, the master begins pouring the tea. But when the cup is full, he doesn't stop. He keeps pouring until the cup brims and overflows.

"Stop!" exclaims the professor. "Can't you see the

The Zen master answers, "That's exactly the situation you are in. Your head is so crowded with thoughts and questions that there is no room left for my answers. Please go away, empty your mind, and only then come back here. First create some space in your head."

Like the professor, many people have overfilled minds. We are vessels of knowledge and thoughts, and we have forgotten how to look with the unprejudiced eyes of a child. We look at the world through the tinted lenses of our experience so we do not enter situations with a blank mind. Painful breakup? There's a big chance that you'll be wary of stepping into the next relationship. Read a good book review? It's probable you'll have high expectations when you get the book. But what would actually happen if we let go of that baggage? If we did indeed look at every situation through

EYES OF A CHILD

"Beginner's mind" is a term from Buddhism. It means that, like a beginner, you have no expectations and no fixed idea of yourself. All options are open and you can go in any direction. You aren't hindered by thoughts like "I can't," "I don't like x or y," or "normally we'd never do that." With a beginner's mind, you're open to the world and the people around you, and you see things as they are, without immediate judgment. According to philosopher Jan Flameling, children naturally operate with beginner's mind. They look at the world as it unfolds with an openness. In their minds, it's a lot more peaceful. They go by their feelings and are open to learning, without any defensiveness.

As we age, we lose that state of being. In the back of our minds, we're constantly haunted by the voice of experience, which wants to comment on all we do. And like the professor in the Buddhist parable, our heads are so overflowing with our own ideas that there's no room left for new ones. The disadvantage of this continual stream of thought is that it seals us off from the outside world. We are so used to thinking that we are seldom able to simply observe. Our rational minds trap us in our own heads, but to make contact with the outside world, we must open our minds.

BECOMING EMPTY

The Zen master offers a solution: If you want to look at the world with fresh eyes again, you must let go of your thoughts. "Emptying your mind," as Flameling calls it, requires "sitting quietly and concentrating on breathing, letting go of your ego and all the thought patterns that go with it. Thoughts will still arise in you, but if you pay them no attention, they'll soon disappear into the background. The more you practice this, the quieter it gets. When it's totally still in your head, you'll be truly in touch with reality: It's a soothing experience."

When you reach this state, you see things very sharply, according to a Japanese study. Scientists looked at the brains of Zen masters and ordinary people meditating in a room with a ticking clock. After a while, the ordinary people filtered out the tick-tock. In contrast, the Zen masters remained responsive to every sound. Their brains registered each tick. Zen masters are adept at evoking a beginner's mind. Research shows that their inner world is an exact representation of the outside world.

Incidentally, you don't have to meditate to empty your mind. That's what we can learn from the philosopher and writer Jean-Jacques Rousseau. In his philosophical guide, *Reveries of the Solitary Walker*, he says that walking brings you back to the absolute simplicity of your existence, relieved of all expectation, satisfied, just waiting—the same state as the beginner's mind. Or, as Rousseau wrote: "I did not worry about me. So I walked with light step, freed from that burden. My heart was full of youthful desires, enchanting hopes, and splendid plans."

FORGET YOURSELF

Even if you've never meditated or don't like walking, you probably have still experienced the mind of a beginner, not just in childhood, but also as an adult. Margrit Irgang describes this in her book, *Zen: Buch der Lebenskunst* "Zen: An Art of Living": "It happens when we forget ourselves. We forget that our skirt is not the latest fashion, and that we should have washed our hair. We're not concerned with the past or the future. We don't make plans and have no regrets. It's as if for a fraction of a second there is a vacuum, without conscious ego. It's a hot day; a car honks outside. Children shout something. And then . . . you have a Zen moment. It happens just like that. Life pours its heart out, unexpectedly, uninvited. It overwhelms us with a glow that is stronger than anything we have ever experienced."

Irgang calls it Zen, Flameling calls it flow, and others call it luck. Whatever the name, it's a state of mind that lets you enjoy life more. According to Flameling, it makes you more social. "If you regularly spend half an hour doing nothing but breathing, you create more space for others. It has made me, a lecturer in philosophy, more alert, more attentive, and more considerate. I don't just tell a story, but I keep an eye on my students to check if my story is coming across. What do they think of it? Do they understand it?"

Above all, a beginner's mind should stimulate our creativity. Research from Radboud University in the

Netherlands shows that, with an open mind, we get faster access to the secret chambers of the brain. Since you are no longer haunted by thoughts, your mind comes to rest and interesting ideas bubble up from the subconscious. It's the old story of scientists and artists getting their most brilliant ideas when they're taking a shower. Rousseau experienced it on his walks. Just seeing a desk and chair made him feel overcome by disgust, which took away all his courage. But when he was strolling along a path, ideas came to him and formed sentences in his head. The paths stimulated his imagination. You don't get that "aha" moment when you're busy analyzing, judging, and comparing. It comes when your mind is empty and receptive.

A LONGER AND RICHER LIFE

Looking at the world through the eyes of a beginner affects your perception of time, says Douwe Draaisma, a professor at the University of Groningen in the Netherlands. He claims time compresses when you do things you have never done before. When we're young, we collect many new experiences and our days are filled with new impressions. But as we get older, we find ourselves in the monotonous grind of life, seldom discovering new things. The scenery stays the same, while it seems the years fly past. If you want to extend the perception of time, Draaisma advises making an effort to discover new things,

A WORKBOOK FOR NEW EYES

At any one moment, our eyes ignore thousands of things that don't matter or that don't seem important at the time. But what if we take the time to look at each thing as if we have never seen it, as if we don't know what it is? Start a journal and carry it with you everywhere, adding to it as you discover new things, or simply rediscover ordinary things with fresh eyes.

because new experiences leave deep traces in our brain.

Asked to look back on their pasts, participants in an experiment associated their most vivid memories with the first time something had ever happened: their first day at a new job, the first time they met the love of their life, the first night in their new home. You can experience many things as firsts, even just by pretending. For instance, at the start of a meal, pretend that you're tasting the dish for the first time. What kind of texture does the food have? Which herbs did the cook use? The key is to create memories because memories "slow down" time. A beginner's mind is not only creative and happier, it also extends the perception of time, which often feels elusive.

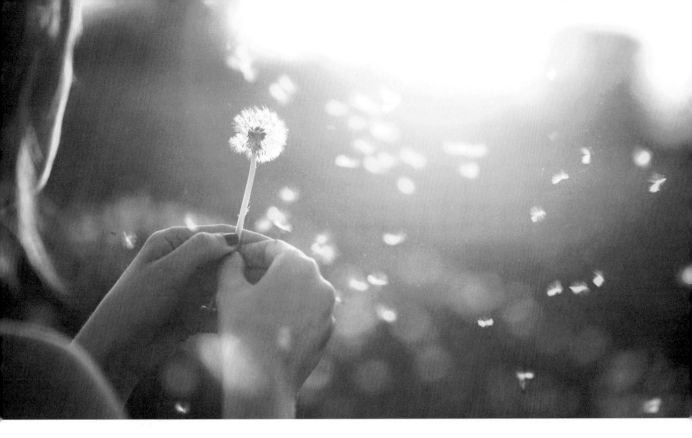

"I didn't see it then, but it turned out that getting fired from Apple was the best thing that could have ever happened to me. The heaviness of being successful was replaced by the lightness of being a beginner again, less sure about everything. It freed me to enter one of the most creative periods of my life." **—Steve Jobs, cofounder of Apple**

"A story has no beginning or end: Arbitrarily one chooses that moment of experience from which to look back or from which to look ahead." **—Graham Greene, *The End of the Affair***

"Ideally, I approach everything as though it's the first time—with a beginner's mind and an amateur's love."

—Willem Dafoe, actor

"I keep turning over new leaves, and spoiling them, as I used to spoil my copybooks; and I make so many beginnings there never will be an end." **—Louisa May Alcott, writing as Teddy Lawrence in *Little Women***

"You can learn new things at any time in your life if you're willing to be a beginner. If you actually learn to like being a beginner, the whole world opens up to you." **—Barbara Sher, life coach and speaker**

The Writing Cure

by Mirjam Windrich
illustrated by Deborah van der Schaaf

Are you troubled by something? Write about it! Organizing your thoughts on paper can put you on a whole new track. You don't need to be a good writer or even spell well to learn how to use therapeutic writing to your advantage.

Writing to gain insights is a practice that has been around a long time. In the classical philosophy of the Greeks and Romans, people were advised to keep a diary to arrive at a better and healthier life. Roman emperor Marcus Aurelius, a representative of the Stoic tradition (in which, it was believed, negative emotions arose from lapses in judgment), expounded on the importance of writing in his personal notes.

Writing is the perfect way to come to inner order and find deep peace. Early Christian philosopher Saint Augustine wrote down his conversations with God to get to know himself better. Other examples throughout the ages include Queen Victoria, who wrote 141 diaries; Virginia Woolf, who wrote several autobiographical accounts of her life; and Anne Frank, who used writing as a way to mentally escape her place of hiding. And then there are the countless novelists who feel that, without writing, life is not worth living. Henry Miller summed up his feeling about writing quite succinctly: "The more I wrote, the more I became a human being."

LANGUAGE PROVIDES MEANING

The idea that writing is beneficial to the psyche has not gone unnoticed in the world of psychotherapy. But while writing in a diary doesn't have rules, *therapeutic writing* requires a bit more structure. Many psychologists believe that it works best if you stick to a single protocol and follow a set of pre-formulated assignments. Using the right analytic tools, you can confront

Sometimes your own words can surprise you.

difficult personal issues, and ultimately move on from problems you've struggled with for a long time.

Dr. Alfred Lange, professor emeritus of clinical psychology at the University of Amsterdam, often employs writing assignments in his relationship therapy practice—one of the advantages being that it's a form of therapy that people can do online.

"As a client, you don't need writing talent or an enormous load of intellectual baggage," Lange says. "As long as you're not illiterate, writing can work well for you." In essence, language does the work for you, as the French psychoanalyst Jacques Lacan put it. Language is a vehicle that not only reflects but also analyzes and gives meaning. Of course, that also applies to talking. It's just that, with writing, other complicating factors fall away, such as nonverbal communication and your relationship with the person you're talking to. You write by yourself, on your own, so it's a kind of withdrawal from the world, a momentary retreat.

HOW IT WORKS

During an online session, your coach or therapist may email you questions: What's going on? How did you really experience an event? What do you really want? The questions start you thinking, and you begin to formulate ideas, and when you start putting your thoughts down on paper, you often think even more carefully. What caused the situation you're in? What are your plans for how to address this?

When searching for the answers, you'll look deeper into yourself, especially if you're trying to find the right specific words and phrases to express yourself correctly. Once you've written them down, go over your text again. Does it say what you mean? Does it correspond with your real experiences? Sometimes your own words can surprise you; they show you something you weren't aware of before. One sentence follows another, and suddenly there's a connection that you hadn't been able to explain—or even see—previously.

Through writing, you look at yourself with care and attention; you observe your inner processes mindfully, with concentrated focus.

WHAT WRITING CAN BRING YOU

In recent decades, there have been many interesting studies on how writing affects your thoughts.

* In the 1980s, psychologist James Pennebaker studied writing assignments for students. His research showed that writing about emotions has a positive effect on mental and physical health.

* Writing has a positive effect on people who are grieving, according to research from Utrecht University. They worry less and experience less loneliness.

* A study conducted in the 1990s at the University of Amsterdam points out that after a few writing sessions, clients were less anxious, tense, tired, and depressed.

* The University of Chicago recently investigated the effects of writing on students who had a fear of failure. Right before an exam, they were asked to write about their anxieties. The results? Their scores on the exams improved. This has to do with the fact that feelings can sometimes act as an impediment to intellectual capacity. When one can deal with emotions safely beforehand (by writing them down), one can concentrate better and retrieve knowledge more easily.

* Dr. Matthew Lieberman, a social psychologist at the University of California, Los Angeles, argues that writing with pen and paper triggers "a kind of unconscious emotional regulation." He thinks this is the reason so many people keep journals.

Mini-Course in
Mindful Analysis
30 Days of Writing & Thinking

by Mirjam Windrich
illustrated by Deborah van der Schaaf

Who are you? What are you thinking? Where do you want to go? You'll answer these questions in this 30-day notebook. Each day, you'll have a question or topic to write about. How, when, and what you write is up to you. The exercises work best if you give yourself time to answer the questions, so try to get comfortable and find a peaceful place where you can write. The questions are all about you and your life. They are arranged according to a method called Mindful Analysis. First, you describe your current situation. Then, you go deeper into reflection on who you are and where you come from. With this foundation of self-knowledge and understanding, you can then begin to explore your options. Finally, you make a real, concrete plan for how you're going to achieve your dreams.

"Fill your paper
with the breathings
of your heart."

—William Wordsworth

Oceans

I have a feeling that my boat
Has struck, down there in the depths,
Against a great thing.
And nothing happens!
Nothing . . . Silence . . . Waves.

—Nothing happens?
Or has everything happened,
And are we standing now, quietly,
In the new life?

Juan Ramón Jiménez
From *The Soul Is Here for Its Own Joy: Sacred Poems from Many Cultures*, edited by Robert Bly. Poem translated from Spanish by Robert Bly.
(Ecco Press, 1999)

Wise Words

illustrated by Deborah van der Schaaf

The following pages are full of wise words from leading figures in mindfulness—the kind of quotes we love to keep in our hearts and frame on our walls.

Drawing words can add to their meaning. That is why hand lettering (see page 44), as it is called, is so much fun. Of all the quotes she reframed in these hand-lettered illustrations, Deborah van der Schaaf was personally most struck by the words of Ruby Wax: "Thoughts aren't facts, so don't take them seriously" (see page 113). "The drawing almost did itself," van der Schaaf says. "I wanted to let the rambling mindfulness 'thoughts' lead the way, as they do, so they could move freely over the page and be written in a free style. Then the words 'facts' and 'seriously' needed to be very straitlaced in contrast. 'Thoughts' and 'facts' are also drawn in contrasting colors: the 'thoughts' in a warm orange and the 'facts' in cold blue.

"The most challenging quote to hand letter was Jon Kabat-Zinn's 'Wherever you go, there you are.' Fitting 'you' in twice was difficult to design well and the curlicues, sticks, and tails all kept getting in each other's way. I made lots of different sketches and versions of that quote, but the final version is the best one for this series."

Wherever you go, there you are

JON KABAT-ZINN

"Wherever you go, there you are."

JON KABAT-ZINN (1944–) is the son of an immunologist and an artist. He says he was influenced equally by both parents; he grew up to be a scientist, but with an open and creative mind. In 1971, he graduated from MIT as a molecular biologist. He got to know mindfulness meditation through Thich Nhat Hanh, the Buddhist monk credited with bringing mindfulness to the West. Kabat-Zinn had an intuition that this kind of meditation could prove helpful in the treatment of chronically ill people—not to cure them, but to ease their pain, anxiety, and stress levels. To be able to study this properly, he founded two mindfulness centers at the University of Massachusetts Medical School in the 1970s. The training of attention that he developed there—and that is now known and used all over the world—is called Mindfulness-Based Stress Reduction (MBSR). Kabat-Zinn has also written a number of influential books such as *Wherever You Go, There You Are* and *Mindfulness for Beginners*. His double-barreled name comes from combining his wife's surname, Zinn, with his own. They have three children.

"Treat yourself as you would treat a good friend."

KRISTIN NEFF (1966–) put the phrase "self-compassion" on the psychological map. It means having the ability to console yourself during painful situations, instead of judging yourself. Neff has proved that self-compassion is indispensable to achieving spiritual balance and health. She stumbled upon the concept through her interest in Buddhism, which began in 1997. Previously, she had done scientific research in moral thinking, authenticity, and the development of self-image. The concept of self-compassion, which is very important in Buddhism, aligned well with her other interests. This led to her groundbreaking research, creating a program to teach self-compassion skills (Mindful Self-Compassion), and writing a book: *Self-Compassion: Stop Beating Yourself Up and Leave Insecurity Behind*. Her writing can be very personal at times: She writes about how self-compassion helped her through a difficult divorce and when her son Rowan was diagnosed with autism. Learning how best to be with Rowan led to the documentary *The Horse Boy*, which she made with her ex-husband. Neff is associate professor of human development and culture at the University of Texas.

TREAT YOURSELF AS YOU WOULD TREAT A GOOD FRIEND

KRISTIN NEFF

Thoughts aren't FACTS so don't take them SERIOUSLY

RUBY WAX

"Thoughts aren't facts, so don't take them seriously."

RUBY WAX (1953–) is an American-born comedian who has lived in the UK for many years and has become a naturalized British citizen. Her father, an immigrant to the United States from Austria, was a wealthy sausage manufacturer in Evanston, Illinois, and her mother was an accountant. Wax pursued a career as a serious actress after studying at the Royal Scottish Academy of Music and Drama (now the Royal Conservatoire of Scotland) and joined the Royal Shakespeare Company in 1978. But her big break happened when she became a TV writer and actress, and later a cheeky interviewer on the BBC. Behind the scenes, however, she had been suffering from depression for years, and this finally led her to mindfulness. Wax went on to earn a master's degree in Mindfulness-Based Cognitive Therapy (MBCT) at Oxford University and to write a funny and insightful book about it called *Sane New World: Taming the Mind*.

"This too shall pass."

ULRICH TOLLE (1948–) became known as the author of spiritual books under the name Eckhart Tolle. *The Power of Now*, his debut book published in 1997, was a number-one *New York Times* bestseller. His ideas about how to find spiritual harmony by focusing on the present moment have inspired countless people—definitely helped by the fact that he doesn't talk about it in an abstract way. Tolle himself arrived at these insights at the age of twenty-nine, after an unhappy and nomadic youth. He was born in Germany, grew up in Spain with his father, didn't finish high school, and, when he eventually went to study in England, suffered a personal crisis. He overcame this crisis by means of a spontaneous spiritual awakening, and he lived, homeless, on the streets of London for two years in a state of blissful happiness, as he describes it. Other people were curious about his transformation, and he started telling them about it, picking up the pieces of his life again and writing down the insights that had brought him spiritual peace. Today Tolle lives in Vancouver, Canada, where he continues to write books and broadcast via his own TV channel.

this too shall pass

eckhart tolle

FILL-IN LISTS

by Jocelyn de Kwant
illustrated by Bodil Jane

"The significance of a man is not in what he attains, but rather [in] what he longs to attain," wrote Kahlil Gibran. In other words, it's important to have goals, whether or not we reach all of them.

A good way to keep track of these goals is by making lists. Not only are they a visual record of your thoughts and feelings at a certain point in time, but they're easy to do—you don't have to write complete sentences or make sure your grammar is perfect. It's more about expressing yourself on the page through words, doodles, color, or anything else you want to incorporate. Spend some time thinking about the prompts, and then write your lists. Once you've filled in (and colored) these pages, revisit them again in three months to see what has changed.

I WANT
MORE OF THIS
IN MY
LIFE

WHAT I NEED
TO ACHIEVE
IT

PEOPLE
I WANT TO
SPEND MORE
TIME WITH

NOTES

PARIS - la tour eiffel

WHAT I WANT TO DO DIFFERENTLY

WHAT I WANT TO STOP DOING COMPLETELY

... AND I WILL DO THIS INSTEAD

Note: Research shows that it's far easier to replace an old habit with a new habit.

WISH LIST

INSTEAD OF ASKING FOR THINGS, YOU COULD ALSO ASK FOR LITTLE MOMENTS OR FOR HELP WITH SOMETHING. (FOR EXAMPLE, YOU MIGHT WANT TO HAVE A CERTAIN LUNCH DATE OR SOME HELP WITH PAINTING YOUR STAIRS.)

Wishes
Plans
Dreams

ON MY OWN

WITH MY ♡

WITH MY
FAMILY

WITH
FRIENDS

WITH...

Celebrate Today

by Otje van der Lelij

How do you shift your focus away from what you don't have to what you do have? When Australian photographer Hailey Bartholomew started a 365-day project to document one thing she was grateful for each day, it changed her life completely.

Hailey Bartholomew led a life that many people dream of. She had a creative job, two beautiful daughters, and a funny, sweet husband. In a garden next to her lovely home in sun-drenched Brisbane, Australia, she grew her own fruit and vegetables. The perfect life, you might say. Yet Hailey was unhappy. She felt restless and dissatisfied. At her lowest point, she wrote in her journal, "I am always tired, and although I love my children to bits and know how fantastic they are, I have little patience as a mother. I have everything, but I find my life uninteresting and I can't enjoy a thing." Hailey dreamed of the day when everything would change and she'd finally be satisfied. "When the kids are older, when my business has grown, when we can travel . . . then I'll be happy."

She was so busy with this vision of the future that she forgot to enjoy all the beautiful things she had at that moment. In search of answers, Hailey sought the advice of a local nun. After a couple of conversations, this wise woman took Hailey by the hand and said, "The key to happiness is reflection and gratitude. All you have to do is dwell on what makes you grateful every day, even the little things."

Hailey grabbed her Polaroid camera and decided that every day for a whole year she would take a photo of something that made her thankful: rows of newly planted basil, a friend's pregnant belly, old Lego blocks that her girls had enjoyed playing with, a single dot of maple syrup on a white Chinese plate. Hailey very quickly became known worldwide for her 365 Grateful Project, which she shared via Flickr, and later turned into a film. She has inspired many people to ask: What is the strength of this project? How can gratitude change your life?

LOOK AND FEEL DELIBERATELY

Everyone knows that feelings of gratitude can bubble up spontaneously at any moment. Yet, in our minds, there's often no room for gratitude. We're too busy worrying, planning, and thinking. According to psychologist and therapist Frans van den Berg, many people are stuck in certain patterns of thinking. We developed those patterns as protection from emotional

pain, but those defense mechanisms can work against us: You might never start a relationship because you're afraid of being abandoned. Or you avoid talking to your partner because, in the past, it ended up in a fight. The problem with many such behavioral patterns is that they tend to shut us down, make us afraid of taking risks, and make us less open to noticing the good things.

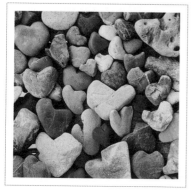

On top of that, our fast-paced society, which requires us to keep up with a constant stream of information, obligations, deadlines, phone calls, and email, makes us distracted and anxious. We take so little time to rest and reflect, sometimes simply forgetting to notice what's good in our lives. As a result, we also forget to be grateful.

But luckily, it's not very hard to develop a sense of gratitude. Mostly, you just need to make a little time for it. We can start by feeling blessed that we are alive. We can be grateful for a nice smile someone gave us at the grocery store, or for a perfect latte delivered with courtesy. We can be grateful for a beautiful flower arrangement, our children's giggles, fresh tomatoes off the vine, the bark of an old tree, or a good conversation with a close friend. And we can be grateful, too, for all the things that aren't wrong—if our country is not at war or that our relationship isn't going badly or even that we didn't miss the bus to work.

Stacks of scientific research already prove that it's worthwhile, from a mental perspective, to practice gratitude. In a study at Kent State University, participants had to write letters expressing their gratitude to the people who had made a positive impact on their lives. The happiness of the participants grew with every letter, as it turned out, and 75 percent of the letter writers felt so good about the experience that they decided to continue writing outside the study. Other studies show that demonstrating gratitude prompts behavior that we regard as moral and good. Thus, grateful people are more caring, more loving, and fairer, and have more respect for others. Also, gratitude dispels feelings of loneliness, emptiness, and jealousy.

"Gratitude elevates, energizes, inspires, and transforms," says a leading gratitude researcher, Robert Emmons, professor of psychology at the University of California, Davis, and founding editor in chief of the *Journal of Positive Psychology*. "It gives life meaning in that it encapsulates life itself." When you're grateful, it makes you happy and protects you during difficult times.

ICE CREAM ON A HOT DAY

By practicing gratitude, Hailey soon began to feel better. In the beginning, she had to look hard for the things she was grateful for, but soon she could not stop finding moments to record with her Polaroid. "Once my eyes were opened, I saw that my world was full of things to be thankful for," she says. "When I'd taken a photo for my project, later in the day I'd think: This moment is even nicer. It's so easy to get caught up in the speed of life, and race from one appointment to another, but this project made me press the pause button occasionally, to cherish the beautiful moments that otherwise would pass me by."

Capturing her moments of gratitude changed Hailey's perspective. After three months, she suddenly noticed a huge change. "I woke up one morning and jumped out of bed," says Hailey. "I was ready for the day, looking forward to what was coming. That hadn't happened for a long time. I remember thinking, 'Hey, this is weird.' And then I realized that I was happy."

It also changed something in her relationship with Andrew, her husband. Hailey had always thought of him as unromantic, but that changed in the course of the year. She discovered that Andrew's type of romance was not in the grand gesture, but in tiny subtleties.

"I remember the time we went out to eat pie and he gave me the biggest slice with the crunchiest crust," she recalls. "And on a sweltering hot day he once came to my studio to bring me ice cream. I never noticed those things at first. Now I do, luckily. This project has opened my eyes to the man I married."

Research also shows how beneficial appreciation is in relationships. Couples who have been together a long time are inclined to take each other for granted. But if you consciously dwell on the little attentions your loved one gives, even if they are very small, it will give a huge boost to your relationship. Couples who regularly show their gratitude to one another stay together longer and are happier than couples who mostly complain about what they're not getting from the relationship.

FLEETING MOMENTS

Hailey's *365 Grateful* blog (365grateful .com) now has hundreds of followers. People can see her project on Facebook, Twitter, and Instagram, or find someone with their own similar project. One person might do it with words, writing something every day. Another person could do it with drawings. New York artist Lori Portka has given her project a new spin: She makes portraits of the people she's grateful

for. Georgia Brizuela felt inspired to capture the best moments with her children on camera. Motherhood is beautiful, but lack of sleep and lots of new responsibilities can make it hard to capture the pleasures; a lot can pass you by. Through her project, Documenting Delight, Brizuela learned the value of her role as a mother and how fleeting precious moments are.

REPROGRAM YOUR BRAIN

According to psychologists, structural expression of gratitude conditions you into becoming a more positive and happy person. Some say it takes weeks, others say it takes months. But after at least a year of practice, your brain is "reprogrammed" and it takes no effort to notice the good in life. Anthropologist Angeles Arrien says gratefulness can also create positive change in the world, precisely because it encourages unselfish, respectful social behavior. The more people there are practicing gratitude, the greater the effect. "If many people choose to practice gratitude at the same time," says Arrien, "we can deliver the collective power that will help create the sort of world that we all hope for and want for ourselves and for future generations."

Mindfulness in Pictures

by Inês Santiago

Pictures can add power and depth to a phrase or word, and may act as portals into mindfulness. Or you can just enjoy looking at them for awhile.

When Inês Santiago moved to the Netherlands from her native Portugal, she didn't speak Dutch. In order to learn the new language, she decided to take a photograph of one thing each day and then attach the Dutch word to it. For example: she photographed a boat and then wrote *bootje* on it. She posted the pictures on her Tumblr blog (adutchwordaday.tumblr.com) and soon had lots of followers, especially other people who enjoyed learning Dutch this way. But there were plenty of native Dutch people following her, too, because her photographs were pretty and it's fun to look at ordinary words from a fresh perspective. "You only truly understand these words and phrases when you are ready to," Santiago says. It was certainly part of her process.

Because she doesn't speak Dutch fluently, she first translated each phrase into Portuguese before thinking of ways to photograph it. "Some of the images I took at sunrise to capture the soft and calm light of that time of day," she notes.

A DIFFERENT WAY?

Allow Life to Be Just as It Is

by Clementine van Wijngaarden

Clinical psychologist and mindfulness coach Tara Brach has known hardships: a mother who struggled with addiction, a miscarriage, and a painful chronic illness. These difficulties, however, led her to find mindfulness, which has changed her life and allows her to help others.

"**M**y earliest memories of being happy are of playing in the ocean," writes internationally recognized mindfulness teacher Tara Brach at the beginning of her book *True Refuge: Finding Peace and Freedom in Your Own Awakened Heart*. "When our family began going to Cape Cod in the summer, we spent hours at the beach, diving into the waves, bodysurfing, practicing somersaults underwater. Summer after summer, our house filled with friends and family—and later, with spouses and new children. It was a shared heaven."

That heaven became tainted for Brach later in her life, when a chronic illness seriously damaged her motor skills so that she was no longer able to walk on sand or swim in the ocean. Brach had to learn how to live her life again—and to love her life, "no matter what."

That was the moment that she began her search "for a place of peace, connectedness, and inner freedom, even in the face of life's greatest challenges." She discovered that, through mindfulness practices and meditation, she was able to find that place of peace she calls "true refuge." Now, she writes, even when she has encountered major loss, she can find this true refuge within her heart and mind.

She learned the technique from several teachers, and it's known as RAIN—an acronym for the four steps one has to take to be at peace with life's hardships. R: Recognition of what is happening. A: Allowing life to be just as it is. I: Investigation with kindness, and N: Non-identification. Rest in natural awareness, or realize that your sense of who you are "is not infused with or defined by any limited sense of emotions, sensations, or stories."

AN EXERCISE IN SELF-AWARENESS

Cultivating an alert and friendly relationship with the top five issues and themes that regularly take over your mind is the beginning of awakening from their grip. Make note of your primary areas of obsessive thinking and write them here. These might include:

- How someone is (or people are) treating you
- Mistakes you are making; ways you are falling short
- Things you need to get done
- Your worries about another person

- How you look
- How you want someone (or people) to change
- What is going to go wrong
- Something you really want to happen

THE TOP 5 THINGS I SOMETIMES (OR OFTEN) WORRY ABOUT:

1. ...

2. ...

3. ...

4. ...

5. ...

Once you have your list, select three that regularly take over your mind and trap you in anxiety, shame, anger, or discontent. Find a name that describes each of these obsessions—several words that are simple, easy to remember, and not derogatory—and write them down, too.

Then, for the next week or two, try to notice when you are caught in one of these pre-identified obsessions. When you become aware that you are, mentally whisper its name and pause. Gently remind yourself that the thought is "real but not true." Feel the inflow and outflow of breath as you check into your body. Is there tension in your chest? Knots in

your stomach? Numbness? Pressure? Breathe with whatever sensations or emotions are there, sensing the energy that underlies obsessive thinking.

Do not try to change the feelings you encounter in any way. Rather, just offer them a respectful, wallowing presence. Depending on your situation, this step of attending to your feelings might take thirty seconds to a minute. Then, take a few full breaths, relaxing with each out-breath, and resume your daily activity. Notice the difference between being inside the virtual reality of an obsession and being awake, in the here and now.

What Are Your Thoughts
ABOUT HAPPINESS?

If you were offered an additional hour in the day, what would you do with it?

...
...
...
...
...
...
...

What small changes could you make to improve your day?

...
...
...
...
...
...
...

What are things you can do tomorrow morning to start your day right?

...
...
...
...
...
...
...

What tiny pleasures would you like to cherish more?

...
...
...
...
...
...
...

TIME TO LET GO

At some point, it all went wrong. While walking to work, we shoved a muffin into our mouth and called it breakfast. We did our grocery shopping in five minutes after a long day at work, heard ourselves too often chide the young people in our house for being too slow, and even put the things we really enjoyed on our to-do list to make sure we made time for them. Something had to give. Or, rather, in the scope of mindfulness, we had to let go: Let go of all the demands we put on ourselves. Let go of the perfect lives we wanted to live. Let go of the idea that one day it would all be better without our changing anything about ourselves.

In committing to this notion, we decided to live less efficiently. And yes, that sometimes means that things can go wrong. Maybe we are a bit too late for a coffee date. Or we forget to pick up the dry cleaning the day it's ready. We are just not as well-organized as we used to be. But we have more fun than we used to, and we're not as stressed anymore. We are generally nicer and easier to be around. Letting go brought us so much—because it allowed us room for the important things.

Let Your Mind Run Free

by Otje van der Lelij

Running is often a very meditative activity, but you can consciously use it as a mindfulness practice with ChiRunning, a method that is focused on pain-free posture, core strength, and relaxation.

In "normal" running, the focus is often on building muscle power, gaining a competitive edge, and crossing the finish line as fast as you can. ChiRunning is about relaxation and body posture. It is a friendly and conscious way of running that tends to lead to fewer injuries and increased happiness.

According to spiritual leader and marathon runner Sakyong Mipham, who wrote the book *Running with the Mind of Meditation*, "body and mind are intrinsically connected to each other, so reducing stress through exercise has an immediate effect on your mind." This has been the case for centuries. "Since ancient times, humans have been aware of the fact that they are happier if the mind is flexible and the body strong," he writes. "In the modern world, we are living in conditions that threaten this mental and physical balance. We sleep less, which leaves us feeling tired a lot. We spend most of our time sitting down."

According to Mipham, we regularly take on too much, physically and mentally. Many people feel stressed out, busy, and unhappy. They have trouble concentrating, want to prove themselves, and are their own worst critics. Mindfulness and physical exercise—or better yet, a combination of the two—are good ways to deal with these problems.

THOUGHTS THAT PUT THE BRAKES ON

Still, it isn't easy to lose yourself in running with your senses only. Mindfulness trainer Kiki Nelissen-Kleipool agrees that your thoughts may still have a tendency to fly all over the place. You might think about that argument you had at work, about an approaching deadline, or even about the running itself: "I've still got so far to go," or "I can't go on anymore," or "I am in such terrible shape." Nelissen-Kleipool says those kinds of thoughts typically put the brakes on your running. "If you are constantly thinking about how many miles you've already run or how many you still have to go, you get tired quicker," she says, "but by focusing your attention on the here and now, you have more energy and you can run for longer."

What you also learn from the mindfulness viewpoint of ChiRunning is that thoughts are just thoughts and are not necessarily true. Convictions such as "I'm not a runner" and "running is not my thing" are also not true. Because it's irrelevant: When you're running, you are running, and that's it. Once you're free of those thoughts, running becomes easier. Even taking note of the fact that you are thinking can bring you back into the moment, says Nelissen-Kleipool. "You 'wake up' and can focus on the here and now again: on your breath, your surroundings, the length of your stride and your posture.

"Of course there are moments when it's harder or moments when your attention drifts," she acknowledges. "But if you simply focus on the technique or on your breathing, the heaviness falls away again." Even learning this technique centers you in the present. When you're learning something new, your mind has less opportunity to drift.

> By focusing
> your attention on
> the here and now,
> you have more energy
> and you can run
> for longer.

A GOOD FRIEND

ChiRunning is not a magic formula that will have you running a marathon in a week's time. You have to build up your fitness level, and your muscles need time to get accustomed to the activity. Sore and stiff muscles and physical tension are going to be part of the process. Mipham says you have to accept these. "It's good to pay attention," he writes. "Mindfulness, for the most part, consists of becoming more conscious of how you feel. Take your stiff muscles or aches and pains and focus on them. By acknowledging them, you break the pattern of avoiding feeling uncomfortable, which is an important psychological step in learning to be present. Maybe you've actually been a bit stiff all day but didn't realize it until you started running."

Another thing ChiRunning teaches you is to be friendly to yourself. We often use self-criticism for self-motivation, like "Lazybones, do something about your health." We hope this will make us run farther. But research shows that self-criticism has the opposite effect and makes you lose confidence in yourself. It's far more productive to talk to yourself as you would to a good friend. "A good friend wants what's best for us," Mipham writes. "They don't yell: 'You're no good at this!' They remind us why we started on this path. They encourage us to keep going." Once you've learned the technique and gotten in shape, you can pay more attention to your surroundings. Then running becomes

more than plowing your way from one milestone to the next. "When you're running in the forest, you can hear the trees rustling, see green all around you, smell the fresh air, and feel the humidity," Mipham writes. "When you're in the city, you hear the sounds of traffic and can bob along in the stream of people."

FOCUS ON YOUR POSTURE

ChiRunning has yet to be studied formally, but there is plenty of research on the psychological effects of being in nature, running, and mindfulness. These three things are all said to lead to creativity, relaxation, happiness, and more headspace. A potent cocktail, in other words, that is bound to have a positive influence on your life.

Juliette Baller from the Netherlands has benefited hugely from ChiRunning after taking courses in it for a few years. "For me, running is sheer joy," she says. "In the beginning, it's quite hard to relax while you're running. But once you master that art, you also start feeling better mentally. When you can let go of all the physical tension, it's easier to shake off mental tension too. That's how it worked for me, in any case. I'm enjoying life much more now. When I'm in the dunes, I feel so grateful. Grateful that I'm able to do this, that I'm able to experience this. It really feels like a gift to me."

The You Can Do It poster, opposite, is a schedule that will help you slowly build up your running routine. The three days of activity are not meant to be consecutive, but spread out through the week. To really master the techniques of ChiRunning, it's best to take a course. Search online to find one in your area.

GET STARTED WITH CHIRUNNING

1. POSTURE
Keep your posture straight, from the top of your head to the soles of your feet. Stretch your body as long and straight as you can. When your spine is aligned, your weight is supported more evenly and you don't rely entirely on your muscles.

2. LEAN
Lean slightly from your ankles, but do not bend from your waist. Keep your spine straight. You'll feel like you're falling and you'll have to take a step to stop yourself from actually falling. Gravity will propel you forward. Each footstep falls lightly on the ground, at the base of your column (never ahead of it).

3. LOWER BODY
While you fall forward, raise your foot from the ground to stop yourself from falling. Don't use your legs in any way

to move forward—only for support while striding. Strike the ground with your midfoot, not with your heel. (When you strike the ground with your heel, your knees and shins suffer; when you strike with the middle of your foot, it cushions the impact on your body.)

4. UPPER BODY
Let your upper body lead the way. Work with gravity by allowing yourself to fall forward. By swinging your elbows backward, you form a counterbalance. This leads to a very natural and relaxed way of running.

5. PACE, ACCELERATION, AND LENGTH OF STRIDE
In ChiRunning, you keep your pace constant. What does change, however, is your stride: the length of your step. As your speed increases, your strides become longer (and vice versa).

YOU CAN DO IT
by Ingeborg Smit

Week 1
DAY 1: 20 min. walking (at a fast clip!) **DAY 2:** 20 min. walking **DAY 3:** 25 min. walking

Week 2
DAY 1: 25 min. walking **DAY 2:** 30 min. walking **DAY 3:** 30 min. walking

Week 3
DAY 1: 2 min. walking, 2 min. running, repeat 5 times **DAY 2:** 2 min. walking, 3 min. running, repeat 4 times **DAY 3:** 2 min. walking, 2 min. running, repeat 5 times

Week 4
DAY 1: 2 min. walking, 3 min. running, repeat 4 times **DAY 2:** 2 min. walking, 4 min. running, repeat 3 times **DAY 3:** 2 min. walking, 3 min. running, repeat 4 times

Week 5
DAY 1: 2 min. walking, 4 min. running, repeat 3 times **DAY 2:** 2 min. walking, 5 min. running, repeat 4 times **DAY 3:** 2 min. walking, 4 min. running, repeat 3 times

Week 6
DAY 1: 2 min. walking, 5 min. running, repeat 4 times **DAY 2:** 3 min. walking, 7 min. running, repeat 3 times **DAY 3:** 2 min. walking, 5 min. running, repeat 4 times

Week 7
DAY 1: 2 min. walking, 7 min. running, repeat 3 times **DAY 2:** 3 min. walking, 8 min. running, repeat 3 times **DAY 3:** 2 min. walking, 7 min. running, repeat 3 times

Week 8
DAY 1: 2 min. walking, 8 min. running, repeat 3 times **DAY 2:** 3 min. walking, 9 min. running, repeat 3 times **DAY 3:** 2 min. walking, 8 min. running, repeat 3 times

Week 9
DAY 1: 2 min. walking, 9 min. running, repeat 3 times **DAY 2:** 3 min. walking, 10 min. running, repeat 2 times **DAY 3:** 2 min. walking, 9 min. running, repeat 3 times

Week 10
DAY 1: 2 min. walking, 10 min. running, repeat 2 times **DAY 2:** 3 min. walking, 12 min. running, repeat 2 times **DAY 3:** 2 min. walking, 10 min. running, repeat 2 times

Week 11
DAY 1: 2 min. walking, 12 min. running, repeat 2 times **DAY 2:** 2 min. walking, 14 min. running, repeat 2 times **DAY 3:** 2 min. walking, 12 min. running, repeat 2 times

Week 12
DAY 1: 2 min. walking, 15 min. running, repeat 2 times **DAY 2:** 1 min. walking, 10 min. running, repeat 2 times **DAY 3:** 30 min. running

Turn the poster over for tips to help you keep going!

THIS TIME YOU'LL SUCCEED

Don't overdo it the first day.
Stick to the schedule, even if the first weeks seem slow. You'll gently build up your fitness and be less likely to get injured. And you'll keep enjoying it.

Always take at least one day of rest each week. Listen to your body.
Stop when you're in pain and wait until you've recovered before starting again. Even if the schedule tells you to run, wait until your body is ready.

Invest in the practical.
Before you get started, buy yourself a pair of quality running shoes from a specialty running store. There, experts can analyze your running style, body type, and feet, and fit you with the right shoes.

Professional running gear isn't necessary, but it's nice.
Made from lightweight materials that breathe and stay dry, they also have handy extras like pockets for your iPod, or fluorescent stripes for night runs.

Eat something substantial at least two hours before training.
Drink a glass of water fifteen to twenty minutes before you go running. After training, have a small snack; this stimulates your physical recovery.

Start your session by warming up and end it by cooling down.
Walking or lightly jogging is suitable as a warmup, followed by some stretches. Don't stretch when your muscles are cold, and keep your stretching gentle. Finish your training by cooling down; bring your heartbeat back to normal again by jogging slowly or walking.

Remember that running can be done anytime, anyplace.
This is great, but can also be a pitfall if you can't motivate yourself. Are you not so self-disciplined? Then find a running buddy or join a running club—they exist for all levels of runners.

Keeping a journal will give you a nice overview of your progress.
By jotting down notes, you can look back and see what went well and what needs improvement. You can boost your motivation by reading through old entries to see how far you've come. The best thing about starting a new activity: Your level of fitness will improve by leaps and bounds.

Don't give up!
Think about all the benefits of running: You'll feel fitter, more energetic, and more productive—and you'll sleep better, too.

RUNNING DIP?
It might help to switch (temporarily) to walking training. This way at least you stay in motion.

The Art of Vulnerability

by Caroline Buijs

It's always hard to admit that you don't know something
or that you need a little help.
Yet vulnerability may be the secret to a happy life.

Vulnerability is the glue that holds relationships together.

A few years ago, I had three life-changing events in a single year: the birth of my daughter, a move to a new home, and a career change. At the time, I would've preferred to bite off my tongue than admit that I was overwhelmed. Instead, I desperately pretended that everything was going perfectly smoothly by turning on the old "I can cope" act. The mere thought of asking for help engendered a deep sense of shame in me. I didn't want anyone to think I was a whiner, and I wanted so badly to keep everything under control.

THE NEED TO CONNECT

If I'd known then about Brené Brown's research examining fear, shame, and vulnerability, perhaps I'd have been less hard on myself.

In 2010, Brown gave a poignant and popular TED Talk, "The Power of Vulnerability," in which she made the case for admitting to vulnerability. Over the years, she's conducted hundreds of interviews with ordinary people, listened to thousands of stories, and discovered that people who dare to reveal their vulnerabilities are happier in life and make stronger emotional connections.

Feeling connected is a primeval need, according to Brown, and when people are able to make better social connections, their lives are richer. "Connection is why we're here," says Brown in her talk. "It's what gives purpose and meaning to our lives. The ability to feel connected is neurobiologically essential."

Brown was fascinated to see two very distinct types of people emerge when it came to vulnerability: people with a strong sense of self, who felt connected to others in positive ways, and people who struggled to get connected. Those who had trouble making connections, according to Brown, feared that they were not worthy of connection. Brown wondered: What do the people in the first group share that explains why they don't have that fear? What determines their sense of pleasurable connection with others and good self-esteem? If she could understand that, Brown thought, then she might find the key to a happy life.

People who connect well, she discovered, have these traits in common:

- They have compassion, for themselves and for others.
- They dare to reveal themselves, including the fact that they are not perfect.
- They are not afraid to be sincere. That means they are willing to let go of the image of who they think they should be and replace that with who they really are.
- They have the courage to be vulnerable. They believe that what makes them vulnerable makes them beautiful. Not that vulnerability is a comfortable feeling, but they accept it.

Brown has discovered through her work that vulnerability is the glue that holds relationships together—"the magic sauce," as she calls it. It is daring to be the first to say, "I love you," without any guarantee that you'll hear the same sentiment returned. "Vulnerability is the core of shame, and fear, and our struggle for worthiness," Brown says, "but it's also the birthplace of joy, of creativity, of belonging, of love."

These discoveries came as a surprise to Brown, who admits that she had difficulty revealing her vulnerabilities, taking off her "mask," and relinquishing control. But, according to her own research, that was exactly what she had to do. So she put her research aside and promptly had a small breakdown. She found herself a therapist, and spent a year exploring why she had trouble allowing herself to be vulnerable. It soon

became a personal quest to discover how she could allow herself "to be seen."

DARE AND DO

When I learned about all this, it brought about a change for me, too. I realized that, in my case, being vulnerable means, above all, daring to ask for help. I find it difficult, because I thought that if I asked for help it would mean I was weak, and I couldn't let myself be weak. But that year of a new baby, new home, and new job would've been easier if I'd been willing to admit I couldn't do everything.

Psychologist Fred Sterk, coauthor of the book *Feeling Stronger: Building Your Inner Strength*, explains that true strength comes from being able to reveal that you have needs, like everyone else. Asking for help is not a sign of weakness. On the contrary, it's a sign of courage.

"You have to dare to go past that vulnerability, not avoid it," says Sterk. "You can't always be giving; you also have to be able to receive. Dare to raise your hand and ask a question. If you find it hard, you'll have to practice it. Adjusting your beliefs, stepping over the threshold, pushing the limits: That is actually the universal in our lives. And if it doesn't work immediately, you might be taking too big a step. Go back and try a smaller step, but you can't avoid taking such steps in your life. That is, if you want to turn your vulnerability into a strength, into something you can learn from."

SAYING "I DON'T KNOW"

Vulnerability can mean daring to say that you are uncertain, that you have doubts. That's not easy in this world, where it seems like everyone always has an opinion about everything.

"We've all been in this situation sometime or another, when a prominent person is sitting across the

table from you talking nonstop about himself," says writer Maxim Februari, a columnist for the Dutch newspaper *NRC Handelsblad*. "He's happy to go on like this for two hours and then eventually he stops to ask, 'And you, what do you do?'"

The person in this example is obviously very pleased with himself, but in this exchange he's not connecting with you, and it seems like he might actually be trying to push you away, to prevent you from knowing him. At the same time, he's also only allowing you time to share the best things about yourself, which means it's very unlikely that he'll get to know you, either. If he had admitted that there was anything he didn't know, or that he may not be perfect, then perhaps you could have a two-sided, balanced conversation.

"We like to present ourselves as perfect," says Sterk. "We show our storefront to others, putting only the best points of ourselves on display. That means we give and get the wrong impression of each other."

The more you invest in perfection, the harder it is to let go of it.

Having an intimate relationship means letting other people beyond the storefront, through the store, and into the home at the back, he says, "because having an intimate relationship means that you get access to the living room, to the bedroom, and to the cellar. That's what intimacy is: being allowed to see more and more of one another.

"And if you're not used to that, or you live life under the false impression that the rest of the world is

perfect, then you've solved the problem of imperfection by avoiding it. When you look in the mirror, you try to cover up your imperfections and you don't get to learn how to handle the associated emotions. The more you invest in perfection, the harder it is to let go of it."

AS RISKY AS FIGHTING FIRES

We tend to think that we most need to be strong at work and in public, and that it's better to be vulnerable in private and among friends. However, career coach Mariska Knauf says that more and more people are starting to realize how vulnerability is also an asset in the workplace.

"In business," says Knauf, "people now prefer a leader to reveal themselves more. Leaders who know where they're heading, but also dare to admit when they don't, and who are open to suggestions."

Among Knauf's clients is a city fire department. "Firefighters are naturally tough men and women," she says. "But here they sit, talking openly and honestly about what they like and don't like about their jobs, and what they find hard about leadership."

According to Knauf, you really see something develop in the group when someone dares to say they find something difficult. Then, she says, you see relief and recognition in the group: "You feel that way, too?" It has a magnetic effect.

But it's always a leap for people to speak openly about their weaknesses in a professional environment, because they're afraid of disqualifying themselves.

"They think if they say that they are no good at this one aspect of their job, everyone will think they're no good at anything," says Knauf. "It's unnecessary to feel that way, because a person can be great at many things and find just one thing difficult. Express it like that: always from the standpoint that you are good enough."

WHAT'S WRONG WITH WEAKNESS?

Now I've learned more about vulnerability, and I'm trying to work at it myself. Every now and then, I notice that something has changed. Maybe you know how it goes: You go out drinking with a friend, but the evening doesn't turn out so well. Or you have dinner with a group of people, but there was no real connection. I've now learned that this happens because I haven't been open enough about myself.

Nowadays, I try to be more frank and open (no matter how hard I find it) about what's bothering me, what I feel insecure about, and truly, I come home with a completely different feeling. Because through my honesty, I connect with people who are in the same boat, and the shame I feel about my weaknesses no longer gets the chance to grow. What's more, I notice that other people often dare to be more open, too, because they empathize.

But that first step: You have to do it yourself. As Brown did, and as I'm learning to do. But to do it, I have to first be kind to myself. Sterk agrees: "If you can get there by being kind to yourself, then you've come a long way," he says. "It's hard, because many people have a strict internal critic. I call it unconditional self-acceptance. It's actually a radical idea: I stand up for myself because I know myself better than anyone else does; I know my vulnerable points and the points I should be ashamed of. Despite them, I accept myself completely."

Or, as Brown says at the end of her TED Talk, "If we start from the feeling of 'I'm enough,' then we stop screaming and start listening. We're kinder and gentler to ourselves, and then we're kinder and gentler to the people around us."

Mindfulness and Love

by Sarah Versnel

What can mindfulness do for you when it comes to love? In love, it so often comes down to expectations and learned patterns of behavior. What if we succeeded in changing expectations? In taking love as it comes?

HOW IT WAS

For me, love used to be so easy. There were boyfriends. One was tall, one was sweet, and one was exciting. Sometimes there was heartbreak (that dissipated quickly), then the next captivating man came along. Love was easy and, looking back, it was mostly because I took life as it came. It was just the wave I was coasting on. Until I was around age twenty, expectations, demands, and plans just weren't part of my life.

As I got older, love became less frivolous. I imagined the way my life would be in ten or fifteen years. I worked and struggled to get there, and I got what I wanted: My college boyfriend and I moved from the city to a picturesque little village. Our daughter was born. We had good careers, a big house, two cars, and two vacations a year. I was a typical thirty-year-old who thought that this was the road to happiness. When I reached the end of the rainbow, I would get the pot of gold.

But guess what? After I'd achieved all the long-term goals I'd mapped out for myself, I took a good look at my life and saw a stressed-out almost-forty-year-old woman who was struggling through a life dictated by her career, perfectionism, and desire to please everyone. I was running on empty.

I tried to control everything. I struggled and planned, caught in a self-spun web of demands about how I should live my life. Like so many young families, we became a little production company. Life was fully booked and not much fun. But there was a pot of gold waiting for me, right? Just over there. So I didn't see what was going on, didn't know how demanding I was. Only looking back do I realize that I could never just "be" in the moment.

I already felt that things were not well in our marriage. I was always nagging and, along the way, had

> I was a typical thirty-year-old who thought that this was the road to happiness.

By allowing the sadness, my sadness finally decreased.

collected a stockpile of grievances. He didn't cook often enough, he bought the wrong groceries, he failed to make that call, he never cleaned up by himself. The list was long.

HOW IT CHANGED

"Acceptance" became my mantra for the next five years. This is exactly what mindfulness is all about. Instead of torturing myself about how things could have gone differently and what I should have done, and instead of overindulging in sorrow or feelings of anger and revenge, I went to one mindfulness course after another. I wish I'd known then what I learned later during an eight-week mindfulness course: There was a kinder and milder way of looking at myself and at my husband. Looking in a milder way doesn't mean not feeling irritated, but it does help us to see why people are behaving the way they are. That it can come from a source of powerlessness, pain, anger, sadness, or fear.

We parted ways. Instead of the pot of gold at the end of the rainbow, there was chaos. Love had failed, along with the dream of the perfect life. What to do now?

Slowly, the penny dropped and I connected to what mindfulness is about: letting things be as they are. I watched myself from a distance. I was full of emotions, but now I knew how to relate to them, and not a moment too soon.

I let the emotions come and go without getting carried away with them. I accepted my sadness and gave it a color (black). I tried to discover where I felt it (a round ball in my stomach). I let it be there without resisting,

and discovered it didn't really become a scary monster. I also looked at my anger (brown, tattered and lumpy), my jealousy (green, of course, and mellifluous), and fear (big clouds, dark blue and red). I learned to separate myself from certain unhelpful emotions.

I sought and found answers in books about mindfulness and other literature. Pascal Mercier, in *Night Train to Lisbon*, wrote:

"What could it mean to deal appropriately with anger? . . . Anger also teaches us something about who we are. . . . We can be sure that we will hold on to the deathbed as part of the last balance sheet—and this part will taste bitter as cyanide—that we have wasted too much, much too much strength and time on getting angry and getting even with others in a helpless shadow theater, which only we, who suffered impotently, knew anything about. What can we do to improve this balance sheet?"

These words made me think about how much time I had wasted being angry, and I tried to distance myself from this emotional state, and not let my irritation build up inside. If I visualized my emotions, I could see that they would pass. Maybe my greatest irritation and sadness came from having to let go of the dream of the ideal family. But mindfulness helped me through the process. It seems so simple, but by allowing the sadness, my sadness finally decreased.

A Beginner's Guide to Mindfulness by Ernst Bohlmeijer and Monique Hulsbergen describes this well: "If we accept our emotions, the power they hold over us gets much weaker, we become less disturbed and more able to live the life we want to. If, on the other hand, we resist our emotional pain, then it follows us all day long, our life stagnates, we waste our energy and we are not able to live the life we want to (a happy one)."

HOW IT IS

And when everything had cooled down, there was room for new love. That was a good thing, but it was also a little frightening. Didn't it all go wrong last time? I had no idea how to do it this time. I had gotten over the disappointment of the last time and had gained many new insights, but could I apply them to love?

I was insecure about how love was supposed to be because, yes, love came with expectations. I wanted to

find a partner willing to make the commitment to grow old together, and I was sad when those expectations weren't met. A part of me was hoping for that all-encompassing love that would just melt away the old dreams like snow in the sun. I really wanted this, and yet this new ideal scared me, too.

I decided to investigate my hidden motivations and enrolled in a course that yielded some beautiful insights. This sentence was a tipping point for me: "Learning to love means having to look in a more mindful way and be more aware of the way we protect ourselves against painful experiences from our child-hood and adolescence, and how we put up barriers when it comes to our love relationship."

I listened dutifully to a "love expert" who said some very sound things. I was holding up a mirror and learning about myself. Why did I like to have to fight for love? Why did I run away when someone was really interested? What were my inner voices saying about love? I wrote down all my unconscious demands, expectations, and thoughts, and I slowly started to discover a pattern.

Mindfulness was helping me, so I reread a lot of books. *A Beginner's Guide to Mindfulness* reminded me: "One of the biggest challenges of living life as a work of art is to not have too many expectations. Expectations can easily lead to disappointment and cause us to miss what is happening in front of us right now."

Armed with these sentences, I reviewed my love life and came to a conclusion: What disappoints me the most are my own expectations. Sometimes I felt like a victim, but much of what had happened had been the result of my own actions and thoughts. These thoughts closed the book on my investigation, and I began to think about what I wanted out of this love business.

And then I met a nice man, whom I'll call "Mr.

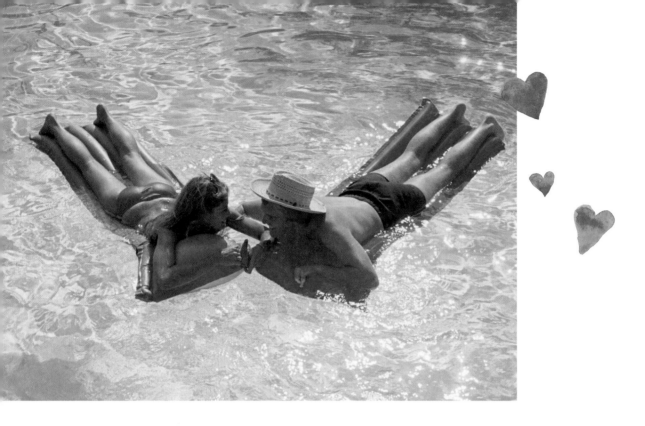

Don't Come Too Close." He had gone through a diffi-
cult divorce and he wasn't quite ready for a new
relationship. He did want to date me, and though we
loved spending time together, he didn't want to include
me in his life with his children or friends and did not
want to plan too far ahead. Instead of being disap-
pointed that I was getting no closer to "my new ideal
family" dream, I saw that I could use a mindful
approach to relate to him.

What if I could just let go of my own expectations,
fears, plans, and ideas of how things should go? What
if I could put them on a cloud and let them drift away?
I decided to try to not get so carried away with my
expectations of new love—I wanted it to be a passion-
ate, larger-than-life adventure, but I was also a little
scared, and when he wanted to get closer, I sometimes
wanted to back away.

And then something special happened. Something
else came into my life, which had previously been so
much about planning and controlling. Space is the
best way to describe it. Instead of pushing "Mr. Don't
Come Too Close" into a relationship, I enjoyed our
time together. At the same time, I enjoyed what I had
in my own life more than ever.

I had more time for my daughter than ever before.
We had the greatest vacations together. I was having a
good time, and, because of this new "space," could
enjoy going out and doing things spontaneously.

I was on my own more than I had ever been before.
Weekends on my own used to scare me, but now I
looked forward to them. I had more contact with my
neighbors, and fully enjoyed my new, uncertain exis-
tence. I had finally eased my way from *doing* into *being*,
which is one of the wisest things I think we can learn
from mindfulness.

I don't know what will happen next with my new
love but I can laugh about it. I secretly chose someone
who is just as scared to make the jump as I am. Thanks
to mindfulness, I see my own patterns and fears and I
can deal with them. I can recognize my thoughts and
my emotions better than ever. And that is as valuable as
a pot of gold.

Let's Stick Together

illustrated by Celinda Versluis

There is a certain joyful nostalgia that comes with a sheet of stickers, but these tiny decorations are also a fun way to add a bit of flair to your journal, planner, notebook, or anything in need of colorful adornment.

Take some time to celebrate the power of women by coloring in the illustrated portraits. As you make your stickers unique, reflect on the important women in your life. What do they mean to you? What do they do that inspires you? What can you learn from them? How can you support their dreams and passions? Being mindful of the role models in your life can help you discover how to be the best version of yourself. Share these stickers with someone special and let her know how much she means to you.

Don't Try So Hard

by Irene Ras

Let things go and don't force them to be right—things often turn out better when you don't overthink them. That's the Taoist concept of *wu wei*.

I started writing when I was about eight, filling pages with poems, little notes, and fantasies, not thinking that anyone would ever read them. Writing was just a hobby, like building huts, crafting, and playing football. But unlike those other activities, writing stuck with me as I became a teenager. I knew other kids who went through the same thing with drawing, or playing tennis, or knitting sweaters. It was something I did without having an audience in mind—not even myself.

When my mother accidentally threw away most of my notebooks during a move, it didn't bother me for long. Those pages had given me something at the time of writing: pleasure, an outlet for self-expression, and perhaps a way to organize my ideas and emotions.

The notion that I could ever earn a monthly salary just from writing simply didn't exist in my world. Writing was like playing outside. How different it is now, years later, when emails from editors regularly drop into my mailbox, asking me if I want to write an article for them on this or that. Not long before that started happening, it had occurred to me that it might be nice to write the odd article, in the evenings, alongside my regular job. Through the grapevine, I began getting freelance work. It was easy; new clients seemed to come along naturally. Then, I said good-bye to my full-time job and began earning my entire monthly income just by writing articles.

Writing for the clients I really wanted to impress, though, made writing, well, a lot harder. In fact, the more I was writing articles for them, the harder I found it. Now that there was something at stake, I didn't want to lose those clients. I couldn't afford to have my editors return my texts filled with red scribbles and lots of questions. I felt I had to be better now that I was no longer just playing around, enjoying myself at the computer. So I sealed off my office and bought a good chair and desk and the fastest laptop, thinking maybe things would go better then. But the fun was gone, and so was the sense of relief when I finished a story—never mind the feeling that my own personal experiences mattered. My brain was a mess. I was trying too hard.

CONSCIOUS EFFORT

Psychologist Daniel Wegner devoted much of his career to studying the paradoxical effect of conscious effort. He found that we can often undermine many of our goals if we consciously try to achieve them. Wegner believed that conscious effort creates exactly the opposite of the intended effect.

We can often undermine our goals if we consciously try to achieve them.

As a researcher, he concluded that we get depressed when we consciously try to be happy, and that we get distracted when we try hard to concentrate. Actively trying to forget something makes us remember it even more. It's like diving into bed early and trying to force yourself to go to sleep. It just doesn't work.

I read about Wegner's research in Edward Slingerland's book, *Trying Not to Try: The Art and Science of Spontaneity*. Slingerland explains how important it is to not always try your best, but instead to do what you want to do. His thinking is based on *wu wei*, an important concept in the Chinese philosophy of Taoism. Literally translated, *wu wei* means "non-action" or "non-doing." It shouldn't be confused with mindless inactivity, though, Slingerland emphasizes in his book. "It just refers to a dynamic, effortless state of mind of someone who is optimally active and effective."

Hmm. Dynamic, effortless, active, and effective—all that sounds encouraging.

DON'T WANT TOO MUCH

Silvia Marijnissen, a translator of Chinese literature, explains wu wei this way: "Don't try to go against the current, but accept the situation as it is." Marijnissen is Dutch but now lives in the French countryside. "Perfect happiness is free of happiness," she says in her explanation of the wu wei concept. "When you live according to wu wei, then you don't need 'have to' anymore."

Sounds wonderful, I think.

"It seems hard," Marijnissen continues. "In the Netherlands, I always let myself get carried away; I was always running. When I got to the French countryside, I didn't have to anymore. Now that I'm here, I find it amazing that I ever achieved anything trying so hard and chasing after everything." But she goes on to clarify that: "It's not that one thing is good and another is not. That's not wu wei. The point is that you can accept how things are going, and that you can find a balance."

Initially, Marijnissen had expectations about her life when she emigrated. "[I had ideas] about how idyllic it would be, living in the French countryside, but even then, I still wanted something," she says. "That's just not the intention of wu wei."

Taoism may be thousands of years old, but Taoist philosophy is still relevant in contemporary Chinese literature—for example, in the work of Mo Yan, the winner of the 2012 Nobel Prize in Literature, and an author that Marijnissen has translated into Dutch. Outlined briefly, his latest book is about the fact that parents in China are only allowed to have one child. One of the protagonists is about to become a father but

1. This picture of my son was taken by my friend and colleague, portrait photographer Linelle Deunk.

2. There's nothing wrong with a beautiful painting, but I prefer my children's notes and drawings.

3. My Volvo 144 from 1968. It's like a moving museum.

As adults, we become too aware of what can go wrong.

he's dreading it. "After all my years of experience, I've come to the conclusion that there is only one way to solve a pressing problem," a friend advises him, "quietly watching it change as it pushes your boat along with the flow."

FOLLOW YOUR FREE WILL

You could interpret "go with the flow" as something insipid, adds writer and artist Roeland Schweitzer. For more than ten years, Schweitzer has blogged on the teachings of Tao. "It's like you're not active, but then you really are, so long as you connect with your inner strength," he explains.

"But inner strength is only a vague term," I say.

He sighs and smiles at the same time. "You know best what your inner strength is; you can feel it," he replies. "You know what makes you happy. Not a chocolate bar, but the beauty of nature. Not a new car, but someone's love and attention."

I get that. The point is being aware of what everything is, not the enjoyment or reward that might follow. "Wu wei is also the art of living," Schweitzer continues, "like you did naturally as a kid. A young child has no expectations and no goals. It's precisely this that allows the child to behave like no adult can."

The older you get, the more you know what mistakes you might make and what the consequences can be. But sometimes this mechanism goes completely crazy once we're adults, he says. We become too aware of what can go wrong.

The whole idea that you have control over what you do—cause and effect—has not matured yet in the brain of a child, but that is very useful, because otherwise you'd never really be able to do anything. Like learning to ride a bike without worrying whether you're going to fall on the hard paved road for the umpteenth time. Like learning to write well, without turning it into a disaster if you get your text back full of corrections in red ink. "Wu wei means following your own free will, without struggling," says Schweitzer.

JUST WAIT

People in the state of wu wei feel like they're doing nothing, writes Slingerland, while at that very moment they might be creating a brilliant work of art, smoothly handling a complex social situation, or, who knows, restoring harmony to the world. His book discusses Michelangelo, one of the most famous artists of the Italian Renaissance, who once said that with every new job, he just waited until he found a piece of marble in which he could see the sculpture. Then he simply pared away the stone that did not belong. In short, not being exactly aware of what you are doing is more effective than trying to do your best.

Clearly, my teenage diaries don't belong in the same category as the brilliant art that Slingerland writes about in his book. But between my eighth and eighteenth birthdays, sitting at my desk up in my room in the attic, I was probably more in wu wei than as an adult writing professionally.

I learned how to ride a bike—as many do—by falling off it often. If I hadn't dared to keep trying, I still wouldn't be able to cycle. Sometimes, when the pleasure of writing threatens to escape me, I think of myself swerving violently on a blue bike. How useful it's been for me, to this very day, that I climbed back onto that high saddle, without getting frustrated, and pushed my foot onto the pedal.

Being somewhere is more important than getting somewhere

Michael Carroll

Happy with
Nothing New

by Sjoukje van de Kolk

Need something? In the past, we might've rushed out to the store for whatever we wanted, but that's changing. Now, more often we're seeking things secondhand, sharing, or borrowing, or simply learning to be satisfied with what we have. It's more sustainable, cheaper, and much more relaxed.

You buy the latest mobile phone and are thrilled at all the useful things it can do for you—until they launch the next version a few months later, and you feel like you've fallen behind the entire world. Manufacturers specialize in this trick. So, en masse, we trot down to the store and trade in our perfectly good phone for a next-generation one.

Gradually, we've come to believe that new is always better, even though it may be just as good to hang on to what we have, because usually it still works perfectly well.

"Companies have been confusing us for years about what we want," says Lauren Anderson, chief knowledge officer of Collaborative Lab, a Sydney-based organization that encourages people to share, borrow, barter, and exchange things rather than buy everything new. "You don't always need the newest of the new."

DRIVING WITHOUT A CAR

These days, it can be easier to have a vehicle when you need it without actually buying it. You can use it for a short time and then return it to the source.

The whole concept of owning things is undergoing a shift, and the status that ownership brings with it isn't the same anymore, argue Rachel Botsman and Roo Rogers, authors of *What's Mine Is Yours: The Rise of Collaborative Consumption*. "We want to fulfill our needs with the material or experience that these products offer," says Botsman. "The products as such are increasingly seen as merely the means to achieving a goal, blurring the distinction between what is mine, yours, or ours."

Partially for economic reasons, and partially because of a shift in social values, Botsman and Rogers write, people are increasingly rethinking the idea of personal property and turning toward conscientious or collaborative consumption.

"People are going back to share with their own community," they write. "The community can be an office, a neighborhood, an apartment building, a school, or a Facebook network. The principle of sharing is very old, but the scale on which it is happening now wasn't possible before."

Trend watcher Andrea Wiegman agrees. "Possession is losing value," she says. "The new generation has less financial stability and earns less than previous generations, but they can save very well. So they don't own a house and there's no car outside the front door."

According to Wiegman, the number of car owners between the ages of eighteen and twenty-nine has

dropped steadily over the last few years in Europe, while just as many young people are still getting driver's licenses. The *New York Times* has reported that fewer Americans are buying and driving cars, too. "It's a reaction to all the overconsumption in recent years," she says.

THE ILLUSION OF SUPPORT

This all fits into a larger trend: opting for quality of life rather than quantity of stuff, searching for more peace, and for doing things with other people. There is a growing awareness that it can be quite liberating to own less. Not everything has to be new in your house, and used items, with a scratch here and there, have their charm.

"We've had a society where things seemed very important, in a world that focuses on outer appearance," says philosopher Jan Bor. "I suspect that all these things give us something to hold on to: 'Look, I did this, so this is me.' That's why we cling to it. But we're becoming aware more often that all these external things only give the illusion of support because, ultimately, all this stuff obviously means nothing."

Bor, who is known mostly for his books on the history of philosophy, says we can learn a lot from the relationship that people have had with stuff in other times of economic and social hardship.

"During the war, my grandmother's house was bombed," he says. "Afterward, she had only a tea towel, a silver spoon, and a photo. Then she told her three sons, 'I'm glad I've got rid of all that rubbish.' In times of crisis—it could be a war, but also an inner crisis, a difficult period—there is always the chance to see the other side, to realize that things really mean nothing. And to realize that feels like liberation."

> There is a growing awareness that it can be quite liberating to own less.

TIPS FOR CONSCIOUS CONSUMPTION

* ONE IN, ONE OUT: Here's a good rule of thumb: Buy something new, throw something out. New book? Then donate another, immediately. New dress? Give one away.

* SET UP A SWAP: Pick a date, drum up some friends, and organize a swap. Clothes, books, bags, trinkets, everything can be traded. Great fun, free advice, and if you're lucky, you'll take a few nice new (to you) pieces home.

* REPAIR! It used to be quite common for people to mend clothes that needed simple repairs. Now we tend to toss anything that's slightly worn without even thinking about it. That's a pity, because it's often quite easy to fix. Take regular trips to your local shoe repair shop, where they can usually fix broken zippers and mend any kind of leather goods, too.

* DISCOVER BAD HABITS: A diary provides insight and is a great way to change your behavior. For one whole month, keep track of what you buy and where you bought it. Want to bet it will include a few unnecessary expenditures?

VACATION DISCOVERIES

by Ellen Nij Bijvank

Vacation is the perfect time to look for creative inspiration. You're relaxed, your mind is clear and open, and you have time to create. Whether you're staying at the beach or in the mountains, make time to go for a walk—nature has some lovely treasures to spark your creativity. Here are some artists and craftspeople sharing their tips and inspiration for what to do next.

HOW TO: PAINT STONES

English illustrator Natasha Newton began making painted stone collections (opposite page, center photo) a few years ago. Each collection begins with a walk along the beach by her home in Suffolk, England. She lives on the east coast, where the beach is made of pebbles instead of sand: the ideal composition. The search may well take some time, because the stones have to look complementary to one another and be very smooth, which makes them easier to paint. She also seeks out a variety of sizes and colors.

STEP 1: Thoroughly wash all the stones and let them dry.

STEP 2: With a very fine brush and a little bit of white acrylic paint, paint a design on the stones. Each design can be determined by the size and shape of the stone. Follow your intuition.

STEP 3: Let the stones dry and then lacquer them with a layer of matte finish. This protects the painting and enhances the color of the stone.

TIC-TAC-TOE

Two players, five stones each.
You can make the grid from
twigs or straws.
eighteen25.blogspot.com

DOMINOES

Needed: dark stones and white paint.
yalos.blogspot.com

COLORFUL GEOMETRY

Straight lines on smooth stones.
giochi-di-carta.blogspot.com

CROCHETED STONE COVERS

Every stone needs a sweater.
haakt.nl

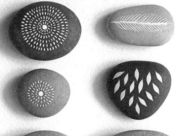

NATURE PRINT

Fossil designs that look
almost real.
natasha-newton.co.uk

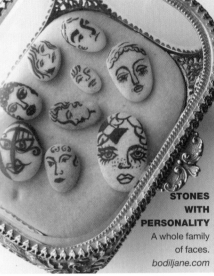

STONES
WITH
PERSONALITY

A whole family
of faces.
bodiljane.com

STORY STONES

Create your own adventure.
craftingconnections.net

STONES TRANSFORMED

Use crochet to turn your stones into flowers.
resurrectionfern.typepad.com

ALPHABET STONES

Add point values for a game of sand Scrabble!
ministryofdeco.blogspot.com

EVERYTHING MOBILE

Everything that you find on a walk through nature can go on the mobile.
imluu.com

PICTURE FRAME

Four branches, some string, and you have a vacation picture frame.
poppytalk.com

STARFISH

Make a starfish with five equal sticks of driftwood and some rope.
thewickerhouse.blogspot.com

GOD'S EYE

Simple and fun to make.
poppytalk.com

PAINTED DRIFTWOOD

Found on the beach and now a colorful reminder of vacation.

HOW TO: CROCHET STONE COVERS

ABBREVIATIONS: ch = chain stitch, sl st = slipstitch, sc = single crochet, dc = double crochet

MATERIALS: ball of thin cotton yarn, a matching crochet hook nr 2, 5/3, a large-eyed yarn needle

STEP 1: 6 ch, 1 sl st in the first ch to form a circle.

STEP 2: 1 ch, 12 sc in the circle, close the round: 1 sl st in the ch.

STEP 3: 3 ch, skip 1 stitch, 2 dc in the next stitch. * 1 ch, skip 1 stitch, 2 dc in the next stitch. * Repeat from * to *. End with 1 ch and in the last stitch 1 dc. Close the round: 1 sl st in second ch.

STEP 4: 3 ch, skip 1 stitch, 1 sc in the next stitch. * 2 ch, skip 1 stitch, 1 sc in the next stitch. * Repeat from * to *, until you crocheted 10 sc. Next: 2 ch, 1 sl st in first ch.

STEP 5: 4 ch, 1 sc in the first sc of previous round. * 3 ch, sc in the next sc of previous round.* Repeat from * to *. End with 3 ch and close the round: 1 sl st in first ch.

STEP 6: 5 ch, 1 sc in the first sc of previous round. * 4 ch, sc in the next sc of previous round.* Repeat from * to *. End with 4 ch and close the round: 1 sl st in first ch.

Keep repeating step 6, but add a ch at the beginning and between the sc for each repetition stitch. Do this until your work fits around the stone.

STEP 7: With a large-eyed yarn needle, weave a thread through the edge of your crochet work, along the last round. Gently slip your work around the stone and pull the thread to fasten the crochet piece snugly around it. Knot the thread and sew in the yarn ends.

HOW TO: MAKE A GOD'S EYE

Photographer Janis Nicolay lives in Vancouver, Canada. "Here on the beach you'll always find the most beautiful wood. My friend Jan Halvarson and I regularly scour the beach in search of driftwood for our creative projects to share on our website, poppytalk.com."

STEP 1: Bind two pieces of wood with yarn so that they form a cross.

STEP 2: Working in a circle, wrap the yarn around them—over one stick and around it, over the next stick and around it, and so on.

STEP 3: To finish, knot the yarn end or create a loop to hang it up.

HOW TO: PAINT DRIFTWOOD

STEP 1: Clean the wood with a damp cloth and let it dry. (Driftwood doesn't need to be sanded, because the sea water has already made it smooth.)

STEP 2: Pick out a few pretty acrylic paint colors.

STEP 3: To paint straight lines, use masking tape to tape off parts of the wood. Paint between the taped parts, let the paint dry, and carefully remove the masking tape.

STEP 4: Alternating thin and wide stripes will look very cheerful, but you can also vary the design with dots, diamonds, or drips.

STEP 5: Arrange the painted pieces on a table or bookshelf or, if you have string and screw eye rings, you can easily make a mobile.

The Beauty of Dreaming

by Mariska Jansen

Everyone has a dream: writing a book, traveling around the world,
or quitting your job and doing something completely different.
Often, the dream doesn't become your reality, even if you nurture it.
And this may not be such a bad thing.

Some dreams are at their most beautiful when left as dreams.

I always had a dream of moving to Berlin. I wanted to roam its streets, unknown to me, and build a life as a journalist there. A good friend of mine dreamed of becoming an artist and turning the art world on its head with groundbreaking exhibitions. Another acquaintance dreamed of becoming a horse groomer. All of us had grand plans for our futures.

According to humanistic counselor Margriet Meijling, making plans is a natural part of youth. "When we are young, we are so full of energy and often think that everything is possible. We want to do things differently and better than our parents and other grown-ups. The world is at our feet. We could become a pilot, get married, or explore the Caribbean by yacht." And, she says, these dreams serve a purpose: "They give us a sense of direction and help us not to get lost in all the choices we have." But life doesn't always go the way we hope it will, and my dream has not become a reality (yet). I started a family and, instead of moving to Berlin, I moved to the suburbs. From time to time, my old dream of living in Berlin whispers: Don't forget, I really want this.

"Every person has multiple ambitions," says author André van der Braak. For instance, we may want to have a family, but we may also desire a career that requires a lot of our attention. The moment these ambitions interfere with one another, it causes an inner conflict.

On a deeper level, this is the battle of our romantic and realistic notions of life. "The romantic view is to never relinquish our dreams," Van der Braak says. "Realism means that circumstances can hinder these dreams. In the best case, a compromise is found or a

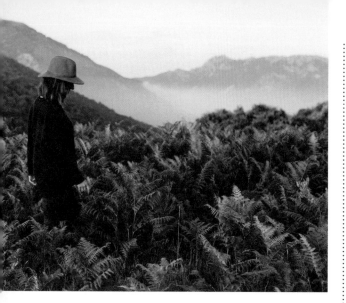

concession is made. We remain loyal to ourselves, to our wishes, but postpone the dream until there is a way to make it happen, at least partially."

My compromise is to move to Berlin with my family in a few years' time. Not forever, of course—that isn't possible—but for a few months or maybe longer. The fact that it's taking me longer than I expected to realize my dream is actually not a bad thing. I evidently needed to take these steps to get there. In the poem "Ithaca," the Greek poet Constantine P. Cavafy writes that trying to realize our dream should allow us to take our time: "As you set out for Ithaca, / Hope that the road is long, / Full of adventure, full of knowledge."

INNER COMPASS

But what if a dream turns out to be unreachable? We can become ill or discover that it is financially impossible. According to Van der Braak, the dream can still serve as an inner compass that can help you to make the best alternative choice.

"Being faithful to yourself means that when you are stuck, you don't pretend that your dream no longer exists," he says. "The dream may be out of reach, but you don't deny this, because to do so is to deny what lives deep inside of you. You must keep feeling this dream."

An unreachable dream is worth examining. It's likely that it is part of the process, and the dream points to a deeper motivation that you can somehow fit into your everyday life. "Ithaca has given you the beautiful voyage," wrote Cavafy. "Without her you would have never set out on the road. / She has nothing more to give you."

Berlin is my Ithaca. Berlin itself may not really matter. It's about my image of a way of life, and the desire to be a stranger somewhere—my need for freedom, space, inspiration, and adventure.

TREASURED MOMENTS

According to philosopher and author Mark Rowlands, humans are so focused on reaching our goals, and yet life is not ultimately about realizing them—and it isn't about the road to our dreams, either. Rowlands explains, with help from the myth of Sisyphus, who was cursed by the gods to push a boulder to the top of a mountain over and over again: "Life on the top of that mountain gazing at a goal he has already achieved is as meaningless as a life spent pushing a huge boulder up the mountain, just to see it roll down again."

Instead, the meaning is found in the moments that fill our lives. "We reach through the moment to fulfill our desires," Rowlands adds. These treasured moments contain everything that really has value. These are the times you are open to the love of others, when you're raising your children or just going for a stroll. At the end of the day, it is tough when our wishes don't (fully) come true. We can struggle tremendously with this, but regrets about missed opportunities can also offer us a certain perspective. "Realizing that we cannot fully control our own destiny humbles us and helps us to accept that things sometimes go differently than we had wished them to," Rowlands says.

As the years come and go, we lose our illusions. We learn that having unfulfilled dreams isn't necessarily bad. Some dreams are at their most beautiful when left as dreams. Maybe living in Berlin would turn out to be disappointing compared with my fantasy of it. So let's not only cherish our dreams, but also our illusions. Write down your own dreams on the next page—and let's go from there.

MY DREAMS

* If nothing could stop you, what would your big dream be?

...

...

...

* What is the most appealing aspect of this particular dream? What feeling or image relates to it?

...

...

...

...

* What part of your dream is within reach?

...

...

...

* What would be the first step toward it?

...

...

...

* Which dream will never come true? Is that such a bad thing?

...

...

...

Angry, Anxious, Jealous?
Being Mindful Can Help

Interviews by Clementine van Wijngaarden

Anger, fear, and jealousy: These emotions often seem impossible to avoid.
But by looking at them in a different way, you can influence how much they affect you.
Three experts teach us about how to deal with these negative feelings.

"Pain is unavoidable, but suffering is a choice." It's an oft-cited quote from Jon Kabat-Zinn, psychologist and one of the leading proponents of mindfulness. Rather than being anxious, jealous, or angry and getting stuck in that emotion (and acting on it), you can make a choice to not be pulled along by it all the way. And then you find that even incredibly strong emotions do pass, all on their own.

Here's a very good metaphor: When you throw a thimbleful of dye into a bucket of water, it will color the water. But if you throw that same thimbleful into a lake, it will have no visible effect. With mindfulness, you can make your heart and mind into a lake: Your consciousness enlarges and there is room for all of the emotions—but without the pain you felt before. It sounds good, but how does that work exactly?

ANGER

by Rick Hanson

"First of all, anger is a signal and it can be a very useful signal. If you look at history, you see change didn't come about until people protested—this is true for

movements ranging from civil rights to women's emancipation. Expressing our anger is a right that we can demand for ourselves.

"Anger comes in many forms. Together with fear, sadness, and shame, it is one of the four 'negative emotions.' And it comes in various degrees: Irritation with something can be shrugged off or it can be vented by bursting into a blind rage. While sadness, fear, and shame make you want to walk away from your emotions, anger is rewarding in a certain way because it gives you energy in the moment, and often you feel like you have justice on your side. But that also makes it possibly the most treacherous and destructive of all the emotions—for others, and you. Buddha expressed it in this beautiful metaphor: 'Holding on to anger is like grasping a hot coal with the intent of throwing it at someone else; you are the one who gets burned.'

"Anger is something that nestles inside you. I know all about it. When I was in my mid-twenties, I had so much anger; it had to come out. I went to dozens of workshops to deal with it. For me, it came from an upbringing where we children were not allowed to show any anger, not allowed to lose control. Everything revolved around so-called 'fun.' We lived in a type of make-believe world.

"The first thing I did was claim my anger. I had been taught to suppress it, and now I had to learn to let it go. It was like a water pipe that hadn't been used for thirty years springing a leak: First a lot of gunk came out and then finally clean water started streaming out. I let it flow. I realized that my anger was an impediment, in the same way an illness can be. And that it was bad for me, and that it kept coming back. Next, I did three things: I focused on it with mindful attention, which helped me discover that under the anger there

were softer, more vulnerable feelings, and I opened myself up to them. I studied them. And finally, I took a vow: that I would not speak or act out of anger again. I took it very seriously.

"At that time I was almost forty years old and I had been working through this for a long time. There'd already been huge improvements, but, for example, in my relationship with my kids, I still wished that things could be better. Too often I was irritated and taking my anger out on them. Thanks to the vow I made to myself, I interacted more slowly. This made me more in tune with the moment. I also tried to figure out what was going on exactly, why I was getting so angry in those moments. Of course, I have to admit I still broke my vow quite regularly, but slowly and surely, I managed to dial it down.

"Taking a step back is important. Looking at it. Not suppressing it. There's a saying: 'What we resist, persists.'

"And yes, of course, one person will have more anger in them than another, we are born that way. And part of it does come from upbringing, but, there, too, mindfulness can be helpful. Gradually you get to know yourself better, and you learn that your body also reacts in a certain way. That maybe you are simply hungry; this

> ## Taking a step back is important. Look at your anger and don't suppress it.

makes your body more reactive and agitated. Or maybe you're tired. Or when you are still recovering from another outburst, the cortisol levels in your body stay up for a while and it takes a lot of time for that to ebb away again. When you look at it that way and recognize all the layers, you'll find that you make it less personal. And you end up feeling naturally more relaxed."

ANXIETY

by Karin Rekvelt

"At this moment in time, anxiety disorders rank highest among mental health concerns, along with depression. Anxiety is an emotion that occurs when you feel like you're in danger or threatened. In itself, it is a healthy reaction—it allows you to respond quickly when you are in danger; for example, jumping out of the way when a car is driving straight at you. Your body and mind have many instant responses: Your heart rate goes up, your breathing accelerates, your body prepares for action, and your mind is in a healthy state of alertness. But sometimes danger can be imagined, or fears are unrealistic, and your body and mind still respond in the same way, as if there is a real threat. This experience can be so intense that you become scared of the reaction in itself and start feeling anxious about your anxiety.

"Anxiety is caused by a wide range of triggers. It is partly genetic and partly influenced by your upbringing.

In his book *My Age of Anxiety*, Scott Stossel writes about his anxiety disorder. He writes that his mother had the same fears that he has, and that his son is also developing these all-too-familiar fears, even though Scott does his best to avoid exposing his son to his own fears.

"Traumatic experiences can be a source of anxiety, and exhaustion can fan the flames of fear. You often see people with burnout (breakdowns) who develop a certain fearfulness. When there has been a long period of time without any relaxation or time off, people forget what it's like to feel carefree and relaxed. This again feeds anxiety and you get caught in a vicious cycle. In periods like this, specific physiological systems gear up: Your nervous system is always at the ready to protect you from danger, you produce stress hormones and tense all your muscles. You end up in an almost continuous state of heightened alertness. The part of your nervous system that is responsible for relaxation and recovery starts to perform more and more weakly, without you being aware of it.

"Mindfulness is very useful because it teaches you to create room for the signals of stress and anxiety by feeling them and noticing them. A usual or normal reaction is not wanting to feel the anxiety. You try to escape from your own emotions or fight them—in itself creating a new source of stress and anxiety. By doing mindfulness training, you learn to stay with your feeling and experience it. You also learn that you can create space for a different—and more comfortable—relationship with your feelings.

"What's more, you can learn to feel mildness and compassion, too. Through targeted exercises, you can develop your recuperative ability and resilience. Feelings of anxiety are a normal part of life, as are all other emotions.

The feelings of fear are still there, but you learn not to make them bigger.

In my groups, I see people with anxiety complaints feeling grateful that they can learn how to not automatically get sucked into them anymore. The feelings and thoughts are still there, but they learn not to make them bigger. People learn that they are not alone, and this realization of shared human experience can give people space to breathe."

JEALOUSY

by Tara Brach

"Jealousy is a difficult emotion, maybe one of the hardest ones to cope with. Like the emotions of fear and anger, jealousy is deeply rooted in the oldest part of our brain, the so-called reptilian brain. This part of the brain is responsible for our primary drive for survival.

"You see evidence of emotions a lot like jealousy among all mammals. I have two dogs, and if I give one of them more attention than the other, the other becomes jealous. People react the same way: If one gets something the other doesn't get, he or she becomes jealous. It is often irrational. I even have a friend who's jealous of his wife's ex-husband, even though he has passed away. Jealousy often goes hand in glove with feelings of anger and shame. It is a complex mix of emotions.

"Feelings of jealousy are as old as humankind, but in our current society they appear more strongly than ever. In a competitive society in which you have to constantly prove yourself and where the message is, 'Be stronger, more successful, more beautiful, and better,' there's a lot of stress. We tend to think other people are managing everything well and therefore they are succeeding in indeed being better, more beautiful, and more successful . . . I've sometimes called that the 'trance of inferiority'—a trance because we are not even aware of it, it's so deeply entrenched.

"We are all made to have all emotions. But what differs from person to person is the extent to which we let them bother us. This has a lot to do with childhood and attachment: People who experienced healthy attachment, who were cared for with love and understanding, will generally be triggered less quickly. That doesn't mean that it's a hopeless case if you are suffering from jealousy. What helps is paying focused attention to the emotion, without judging; then it loses its impact. You

What helps is paying focused attention to the emotion, without judging; then it loses its impact.

leave out the thoughts about others and take a look at what is really going on in your body.

"There are two steps: It starts with not condemning yourself. Jealousy is an embarrassing, painful experience. But you can't do anything about it and it's not your fault. So look upon it with self-compassion. Tell yourself: I can't do anything about this. Next, pay attention to it: What is this jealousy trying to say to me? That I am not good enough? That the other person is better than me? Look at the thoughts you have. Feel what's going on in your body. Where do you feel the jealousy? Do you feel it in your heart? Is it constricting your throat? Be friendly to it. You'll soon find that more options open up to you. If you can calm yourself down instead of offloading on other people, you will discover what a relief it is. Then you will find your power and your self-confidence and be able to free yourself from the grip of jealousy."

Mastering the Art of Quitting

An interview with psychology writer Peg Streep
by Renate van der Zee

Persistence pays off, we always hear.
But there's also an art to knowing when to stop.

WHY DO PEOPLE NOT LIKE TO QUIT?

Various studies show that humans are programmed to always keep on going. In evolutionary terms, it's only logical. If you're a hunter, it makes perfect sense to keep going. If you nearly shot that caribou, it's smart to keep trying, because gradually you will learn how to handle your bow and arrow so that you can shoot to kill. That's how we're programmed, to regard something that is not successful as something that almost succeeded. We just have to go on. But now we apply that unconscious thought pattern to situations where it may not be as beneficial. For example, say you have a dreadful boss. You know he or she will never change, and that you'd be better off looking for another job. But then one day your boss is a bit less terrible and you say, "Oh, things are looking up; maybe working here can still be good for me." In your brain, a light switches on and says, "We almost got that caribou." But it's not always true.

WHY DO WE VALUE PERSEVERANCE SO MUCH?

It makes a great story. Someone who writes an instant bestseller is not interesting. No, we love the story of someone who wrote seven books that didn't sell at all, and in spite of that, they go on to write that eighth book, which makes it big. Such a story inspires people, but they forget that you don't score success through perseverance alone. If you had no writing talent, you could go on publishing books indefinitely, but none of them would ever be a bestseller. In that case, it's better to stop and do something else that you might be better at.

WHY IS QUITTING IMPORTANT?

In Western culture, the people who strive are heroes and those who give up are losers. Quitting is really only appreciated when it comes to smoking or drinking. In America, there's the dream of the newspaper boy who becomes a billionaire through hard work and grit. But sometimes we hang on so hard to what we want to achieve that we forget to check if it will actually make us happy in

the end. If you quit at the right time, you free yourself to pursue something that might give you more satisfaction.

HOW DO YOU KNOW THE RIGHT TIME TO STOP?

First, try to find out if you're focused on avoiding failure or whether you're focused on results. If you are risk-averse, you'll want to avoid the risk associated with stopping. Then ask yourself, how realistic are my expectations? If you want to quit your job and try something new, you have to have a realistic idea of your talents. Don't set goals that don't fit who you are. If I wanted to be a professional ballerina, for example, it would be a hopeless undertaking. I know that very well. How many people are determined to be writers and singers without checking first if they have the talent to do it?

SO, YOU SHOULD HONESTLY ASSESS WHETHER YOU'RE CAPABLE OF SUCCEEDING?

Yes, many people get stuck in situations not only because of the unconscious tendency to persevere but also because they have a lack of self-knowledge. Are you tempted to think that by sticking around longer in situations that are not good for you, they'll improve? A little pessimism is very healthy when it comes to quitting. I'm not talking about the kind of stopping where you storm out of the room and slam the door behind you. I'm talking about consciously detaching yourself from the unattainable goal that you had set for yourself so you can make room for something new instead.

FOR INSTANCE . . .

I was just finishing my thesis (which I'd worked on for years) when I realized that I was just not happy in academia. I couldn't stand the constant competition. So I quit and went into publishing. Then I quit publishing for exactly the same reason. Ultimately, I became a writer, and it worked. Both times it was terribly difficult to untie the knot. We get motivated by the time and effort we put into something, whether it be a marriage or a career, and we call out in despair, "How can I stop now, when I've devoted five years of my life to this?"

SOMETIMES FAMILY AND FRIENDS AREN'T SUPPORTIVE.

Yes, if you decide to give up your job, for example, you may get nasty comments from people, especially if you have a family and responsibilities. Especially if you're quitting your job to go do something that earns a lot less money. In my book, I tell the story of a successful lawyer who didn't like her job but it took her fifteen years to quit. Every time she wanted to bite the bullet, someone said, wait until you're a partner in the firm, or wait until you have saved more money, or wait until you can retire. Now she's a schoolteacher. She earns a lot less, but she's very happy. When people do what they find satisfying, high salary or status isn't as important.

WHAT'S YOUR ULTIMATE MESSAGE?

Heroism isn't only found in perseverance; it can be just as heroic to *stop* persevering. It can be terrifying to quit doing something; you don't know if things will turn out as you hope. Yet, the key to a happier life is daring to accept that something isn't working for you and making room for new opportunities. Quitting is never the end. It's the first step to a better future.

TIME TO BE KIND

It happens so often: There you are, lying in bed at the end of the day, recalling all the bad things that happened. Things you forgot to do at work, a talk with your partner that didn't go as expected, or any number of small things you feel might be wrong in your life. As a society, we excel at getting ourselves down!

So the challenge, then, is to be kinder—and not just to each other, but to ourselves, too. Try ending the day gently, with a little reflection and self-compassion. Go to bed thinking about all the nice things that happened, focus on the lovely parts that were there, instead of chewing over the bad stuff. (At least if the bad stuff insists on rising to the surface, it's tempered by the good.) Recall the compliment from a coworker, the small item you crossed off your to-do list, or the driver ahead of you who paid it forward at the toll booth this morning.

It's difficult, changing a habit. But research shows that you can train your brain to think more positively and be kinder to yourself. Keep practicing. Move over, self-criticism.

What Do You Give Yourself?

by Roos Ouwehand

In an era when we have so much, when we give and receive so much, there are still things that we don't get enough of. Time, for example. And we often have far too many regrets.

A couple of years ago, an article in *The Guardian* became an Internet sensation. "The Top Five Regrets of the Dying" focused on Australian nurse Bronnie Ware, who'd written a book about her experiences nursing terminally ill patients.

After several years working in palliative care, Ware noticed that when her patients looked back on their lives, almost all of them mentioned very similar regrets, number one being: "I wish I'd had the courage to live a life true to myself, not the life others expected of me." The second, voiced most often by men, was: "I wish I hadn't worked so hard." The next two: "I wish I'd had the courage to express my feelings" and "I wish I had stayed in touch with my friends." Lastly: "I wish that I had let myself be happier."

When I read these statements, they affected me deeply; each one, in all its simplicity, was so familiar to me. I started imagining how those lives could have been lived differently. All the things left unspoken, the repressed desires and thwarted dreams. They forced me to recall the times I just stared at the floor because

MONEY VS. TIME

In a recent article "If Money Does Not Make You Happy, Consider Time," scientific researchers at Stanford University wrote that how you manage your time has more impact on happiness than wealth and material objects. In fact, the very thought of having money makes people less inclined to do things that make them feel happy. The scientists went on to list simple activities that enhance happiness:

1. Spend time with people you like.

2. Think up things you would like to do. Ask yourself: "Will what I'm doing now add value to my life in the future?"

3. Spend time on these activities.

4. Make time last by living intuitively in the moment, not with your mind on the future.

I didn't have the guts to say "I'm afraid," or "I love you," or "you hurt me."

I regret the fact that I almost never see that little group of old school friends with whom I always had such fun. Or that I force myself to do things only because I know my family or culture expects me to.

That fifth regret I find the most poignant of all. Ware says, "Many people realize only at the end that happiness is a choice." Patients confided in her that they had become trapped in the routine and the familiar. And, they'd had to face the fact that they'd only fooled themselves. They'd pretended to be content with their lot, whereas they'd actually longed for something entirely different.

FILLED WITH REGRET

What shocked me most was that we have to be teetering on death's doorstep before we actually sort out the major and minor issues in our lives and how we want to manage our time here on Earth. Shouldn't we be able to decide here and now how we want to invest our time and energy, so that when we reach the end of our lives, we won't be stuck with such a tragic list and a heart filled with regret?

It wasn't until I turned forty that I started to realize that life lasts but a moment. When I was eighteen, I simply had no idea how quickly time would pass. All those hours I spent sleeping in my bed as a teenager really would never come back. But the silly

From now on, I want to spend as little time as possible in ugly shops with loud music.

thing is that once I knew that the weeks, the months, and the years would roll by at an increasingly faster—and soon hysterical—pace, I still pretended I had all the time in the world, as if it wasn't a finite, exhaustible resource.

CELEBRATE LIFE

Time is money, as the saying goes, but that's nonsense. Time is worth far more than money. It is the beginning and end of everything. Together with our health, time is our most precious possession. When we have it, an ocean of opportunity opens to us. We can walk on the beach. We can drop in on our mother and surprise her with a little something from that delicious cake shop. On a rainy Thursday afternoon, we can go to a movie alone. We can daydream. Braid our kid's hair. Delve into astronomy or etymology. Build things. We can finally make up with that friend whom we hurt so badly.

We do these things already. Every now and then. But in between there is a great deal of static. So many hours filled with careless moaning and whining about a flat tire or the bus that never comes, for example. Or trudging aimlessly along a busy shopping street.

WASTE OF TIME

Of course, there are moments when we cannot really experience all that life has to offer. There are work and chores and days when it feels like the world is one big conspiracy against us: The gym bag has disappeared, the rain splatters against the windows, and a road-raged driver cuts you off on your bicycle. And there

you are, standing drenched on a Monday morning, wet to the bone, cursing indignantly. There's no escaping the sheer misery of it, without some kind of Zen Buddhist miracle.

The problem is that we are often stuck in such situations, and for the rest of the day—or week—we're grumbling about "that jerk who kept driving." The same applies to fears and insecurities. Of course, this is part of life, but still, we let them pile up over time, until something that was once insignificant overwhelms us. We'll lie awake all night rehashing a conflict. We'll muddle through those vague I-don't-feel-so-good-and-don't-know-what-I-want phases, put up with work situations we abhor, and cling to friendships long past their sell-by date. Stuck in a rut, in a state of slight dissatisfaction with absolutely everything—that, I think, is the real waste of time.

INTENSE DESIRE

This is the precise dissatisfaction that compels us to go shopping. We trudge to the shops, driven by an intense desire to buy something, anything, to fill this void. We go out into the gray, unfriendly fray to buy bags full of junk we can't live without, coming home tired and haggard.

And the satisfaction—if any—doesn't last long.

CHEERFUL ADVENTURES

Those shopping bags don't offer any real help. They provide a moment of joy, perhaps, but that's it. If you ask people on their deathbed to recall the highlights of

their lives, I can't imagine anyone answering: "The time I bought Cavalli boots."

The only real solution is simple: Buy less stuff you don't need. This saves both money and time. Precious time that we could better spend on fun. Why don't I ask my son, "Will you come camping with me one night?" Or why don't I have a solitary experience? I'll never forget my trip to Beijing—the nights I spent in a strange hotel, in that hard, lonely bed. Aren't these both a better remedy for my nagging dissatisfaction than a nonstick pan?

For we all know that adventures cheer us up. Indeed, scientific studies confirm this. Having an experience gives us something to anticipate. Afterward, we reminisce about it with friends or relatives, creating and strengthening these bonds by sharing our adventures and memories.

THIS IS MY LIFE

Bronnie Ware's story lingers in my mind. It's made clear to me that I must remind myself that this is what I have to go on. This life is all I have to do all the things I dreamed of and longed for when I was lazing in my teenage bed.

Having an experience gives us something to anticipate.

I don't think my life needs to be an unbroken set of highlights, or that I need to bounce from high to high.

But I don't want to be stuck feeling angry at irritating motorists. I don't want to worry about things I cannot change.

From now on, I want to spend as little time as possible in ugly shops with loud music blaring from speakers.

Now I'm forty-four, and I increasingly understand that life is short. I want to fill the rest of my days having big and small adventures with the big and small people I love—not with nonstick pans. Because later, at the end, I don't want to be stuck with a heart filled with regrets. I don't want to say to the person holding my hand that "I wish I had let myself be happier."

Letter to
YOURSELF

Take a moment to write yourself a nice letter.
What are you worrying about too much? What could you let go of?
How can you better enjoy what you have? What things are already
going well in your life? Give yourself some advice.

"Advice is like snow—the softer it falls,
the longer it dwells upon, and the
deeper it sinks into the mind."

—Samuel Taylor Coleridge

Date ..

Dear ..

..

..

..

..

..

..

..

..

..

..

..

..

..

..

..

..

..

..

..

..

..

..

..

..

..

♥

POETRY PICTURES

Dutch children once collected little "poesieplaatjes," or poetry pictures: illustrations you could punch out of a paper background, collect, trade, and save. Here, five illustrators have made modern, grown-up versions for you.

Illustrator **Geertje Aalders** makes cheerful fairy-tale scenes out of paper, cut out and put together entirely by hand. "I combined an apple-picking squirrel with the story of Little Red Riding Hood. She's off to her grandmother's on her scooter for cake, and on the way she picks a basket full of apples and a bunch of flowers." geertjeaalders.nl

As a child, illustrator **Nathalie Lété** loved scrapbooks, which she decorated with poetry pictures of flowers and roses—some of which had glitter. "I looked in my album every day, and it made me so happy." nathalie-lete.com

Illustrator **Hanna Melin** loves dogs: "I love naughty dogs with happy faces. They make you laugh—even on rainy days." Hanna sells her work on Etsy and in galleries all over the world. hannamelin.com

Graphic designer **Annemoon van Steen's** distinctive work uses many different techniques: paper collage, fabric, needle and thread, drawings, and watercolor. "The beautiful nature of autumn inspires me. I drew my sheet in soft pastels and included a stork, as well as lots of little beetles, just because I love them." annemoonvansteen.com

Illustrator **Caroline Ellerbeck** is best known for her colorful wall hangings of dark fairy tales. This time she turned those stories into a sheet of poetry pictures. "I love classic fairy tales; they tell a story, they're exciting and colorful and give me lots of inspiration." carolineellerbeck.nl

Open the envelope to discover five sheets
of poetry pictures.

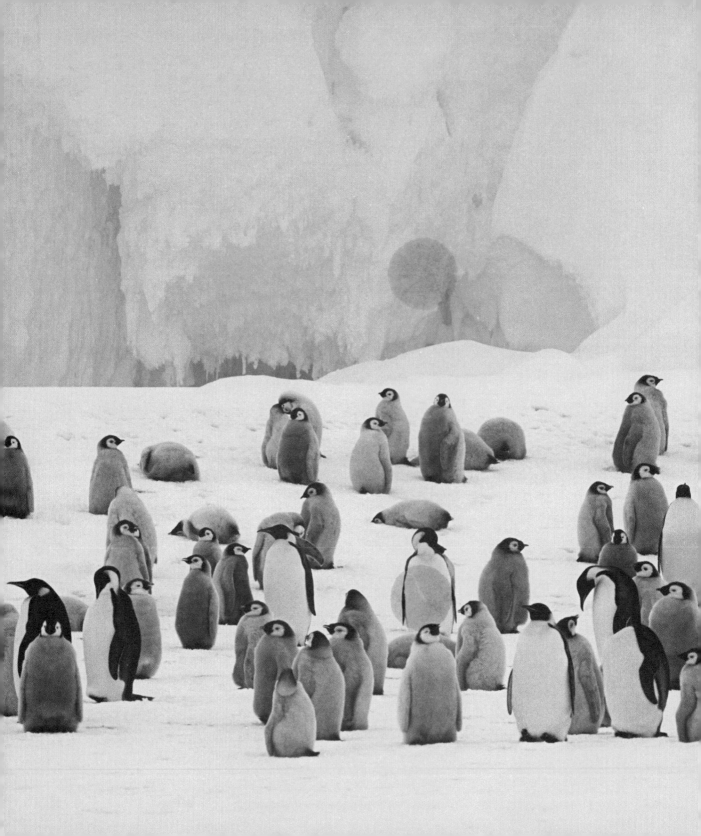

Together Is Better

by Caroline Buijs

After years of individualism, we seem to be spending more time doing things together again. What set off the change, and how long will it last?

As a child, I feasted on family stories about "how it used to be" when my parents were young. I especially loved my parents' story of their first Christmas together as newlyweds at the end of the 1950s. Nothing particularly startling happened. On the contrary, the story was just about how nice it was for them to spend time alone together as a couple rather than with the whole family.

The year my parents celebrated their first Christmas together was also a moment in history when society was beginning to autonomize and focus on social independence. People were increasingly making their own decisions and not blindly following the directives of their social groups—be they religious, cultural, political, or other. From the late 1950s until now, there's been a strong movement toward individualism; Western culture is as individualistic today as it's ever been.

But people remain social creatures. We've been socializing for as long as we've existed. When Socrates had to choose between the cup of hemlock or exile from Athens, he chose death rather than to live apart and alone. Alone, we cannot survive.

On the other hand, we are individuals, and sometimes too much togetherness can feel overwhelming for us. You start to lose your sense of who you are, and your identity starts to become tied up with the group.

ONLINE VS. OFFLINE

So, where are we now? In some ways, we're a very individualistic society, but we've seen the emergence of a strong sharing economy via the Internet. Through all kinds of social media sites and apps, we now swap and trade to our hearts' content.

Clearly, social media does connect us in new ways, but it's not always effective. New research shows that people

Getting together virtually is so easy, but it's just as easy to break up.

actually feel lonelier the more they connect only through Facebook or other platforms. Trend watcher Carl Rohde says: "The online world offers lots of new contacts and relationships, but at the same time, all those contacts are so easy to 'click away.' Manners are changing: For example, ending a relationship by text message is now normal. Getting together virtually is so easy, but it's just as easy to break up. That's going to bother us, and as a reaction, we're going to want to be together again, offline, in smaller groups."

Trend analyst Christine Boland thinks that the next logical step in the sharing economy is to want to make ourselves available to a smaller circle of contacts. People will become less public or more selective in how and where they broadcast their interests. The app Snapchat allows you to share photos with others for up to ten seconds before they disappear. And Instagram makes it possible to share a picture directly with one person, without all your followers looking on.

SMALLER CIRCLES

What will "offline" society look like in the next decade? Will we go on sharing? Will we be seeking human connections in "real time"?

Boland predicts that the sharing economy will continue to grow. It's only in the beginning stages, she says, and people are just developing a taste for it. Sharing doesn't necessarily need to be restricted to material goods; it can be intangible things, too.

"The world is becoming flatter and more transparent," explains Boland, "and the effect of that transparency is that increasingly we see through things (or people) that are fooling us. As consumers, our illusions are being stripped away. Moreover, the economic crisis has added a lot of uncertainty to the mix. What you then see is people needing new small circles of trust and new small circles of togetherness."

SHARE THE COMFORT

* Have you and your friends ever dreamed of living together as oldies in one house? Check out this beautiful French movie, *Et Si On Vivait Tous Ensemble?* (*All Together*).

* Here's a nice idea: camping in someone else's backyard. (Preferably a lush English garden, of course.) On campinmygarden.com you can find people who want to share their gardens with you.

* Granny's Finest is a knitwear fashion label that combines the creativity of young designers with the skills of grandmothers. This social enterprise does not focus on profit, but on solving social problems—in this case, preventing loneliness among older adults. **grannysfinest.com**

INTERGENERATIONAL LEARNING

The concept of "sharing the intangible," especially between generations, can produce amazing results, as

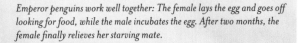

Emperor penguins work well together: The female lays the egg and goes off looking for food, while the male incubates the egg. After two months, the female finally relieves her starving mate.

Sir Ken Robinson writes about in *Out of Our Minds*, which describes a kindergarten that was situated inside a retirement home in Tulsa, Oklahoma. The residents had all the time in the world to help the children, especially in teaching them to read. And guess what? More than 70 percent of the kids finished kindergarten with the reading skills of a third-grader or higher. The residents gave them individual attention, and through these relationships, the kids learned far more than just reading. On the other side, the adults gained a new purpose in life, which gave them new energy, and, strikingly, their use of prescription medications dropped dramatically.

A comparable project took place in the Amsterdam neighborhood De Pijp, where elementary school students interviewed older people in the area about their childhoods during World War II. The kids then wrote a book based on these oral histories. The older people found it inspiring to work with the curious children, and in some ways their preconceptions of the younger generation were changed. The children learned about history from people who'd actually lived through that history and, through the process, also learned new social skills.

SHARED SPACES

Trend watchers have observed that new types of housing are emerging for people who want to bring the sharing economy into their homes. In Germany, groups of singles are buying buildings to use as a new form of cooperative-style housing, with individual rooms but plenty of common space. In Japan, architects are building homes that allow people to add a temporary annex onto a house, if, for example, the kids move back home after university. Carl Rohde predicts that more people will build flexible homes that can be adapted to changing familial circumstances.

SHARING IN THE FUTURE

There's no telling what kinds of inventions will come from the shift toward sharing. There's so much room

"Coming together is a beginning,
staying together is progress,
working together is success."

—Henry Ford, American industrialist

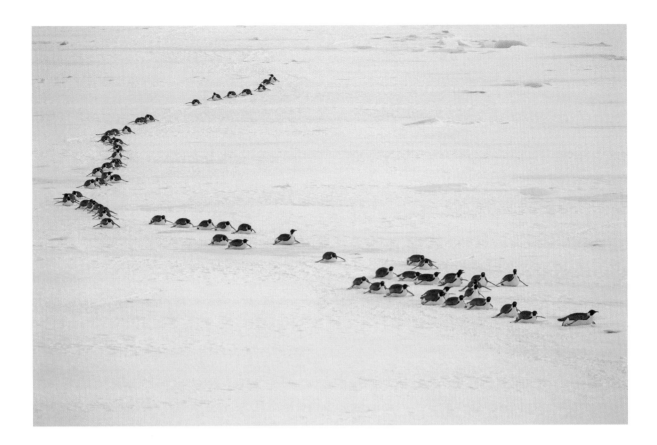

for innovation when it comes to shared vehicles, for example.

The website shareable.net keeps its readers up to date about the sharing revolution, with articles about new movements such as crowdfunding, ShareFests, and coworking spaces. There's also a community section where people can collaborate on local projects, or just learn about such projects near them. Shareable's cofounder and chief editor, Neal Gorenflo, says the results of the "market economy" are not positive, so it's time to come up with a new model. Gorenflo talks about ideas like participatory budgeting, where citizens allocate their own tax dollars to projects they support, and public banking, where the investments go into the local community. And it's catching on. Founded in 2009, Shareable—dedicated to solving some of the world's more persistent problems simply by learning how to cooperate, collaborate, and share—already has millions of participants worldwide.

..

WANT TO READ MORE?

* *All That We Share: How to Save the Economy, the Environment, the Internet, Democracy, Our Communities and Everything Else that Belongs to All of Us*, Jay Walljasper (New Press, 2010)

* *What's Mine Is Yours: The Rise of Collaborative Consumption*, Rachel Botsman and Roo Rogers (HarperBusiness, 2010)

* Ken Robinson can be found at sirkenrobinson.com

* Carl Rohde can be found at scienceofthetime.com

Being Together, Being Alone

We are social animals, and we need one another. Competition, distrust, and self-promotion at the expense of others tend to make us feel isolated and lonely. Societal change needs to come from people doing what "feels good"—that is, coming together to build trust. But far too often, we're doing what we think we should do, rather than what actually feels right.

1. **Who haven't you seen in a while and would like to see again soon?**

 1. ..

 2. ..

 3. ..

2. **What have you been longing to do (visit a new town or city, go for a long walk, etc.)? Can you combine doing one of those activities with a person you thought of in the previous question?**

 1. ..

 2. ..

 3. ..

3. **When was the last time(s) you felt really alone? (Did the feeling last long?)**

 1. ..

 2. ..

 3. ..

4. **Where do you feel loneliness in your body?**

 1. ..

 2. ..

 3. ..

 4. ..

5. **What are your favorite things to do when you are on your own?**

 1. ..

 2. ..

 3. ..

 4. ..

6. **What are your favorite things to do when you are with someone else?**

 1. ..

 2. ..

 3. ..

Try a Little Tenderness

by Sjoukje van de Kolk

When you judge yourself less and allow for mistakes, you live a more relaxed life. A course in self-compassion teaches us to look at ourselves in a kinder and friendlier way. And yes, this can make you happier!

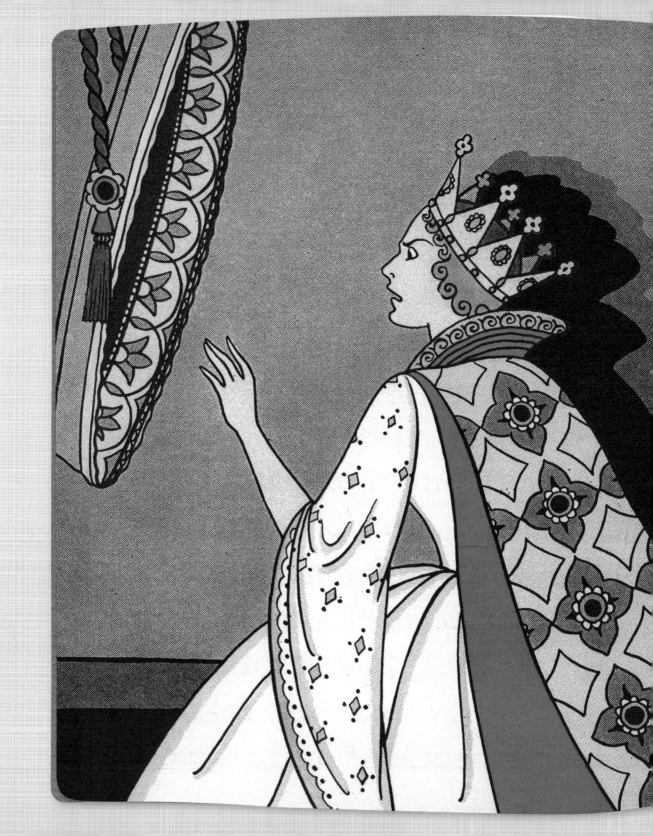

There's a classic Otis Redding soul tune, "Try a Little Tenderness," that offers a man advice on how to treat his woman when she's weary. "It's not just sentimental, no, no, no," Redding croons. "She has her grief and care, yeah, yeah, yeah. But the soft words, they are spoke so gentle, yeah, it makes it easier, easier to bear."

Sometimes a little tenderness is just what we need to give ourselves, too, when we are weary. But far too often when something difficult happens in our lives, instead of giving ourselves those needed "soft words," a critical voice inside us pipes up to make matters worse. It's always happy to whisper into our ear that we could have done better, some way, somehow. That we could have been better as a mother, partner, colleague, neighbor . . . you name it. We are, it turns out, great at criticizing ourselves.

Why is it so hard to be kind to ourselves, especially when we're in trouble? According to Kristin Neff, a professor at the University of Texas, who has carried out extensive research on self-compassion, it's due to Western society's competitive nature. "The bar is high, the emphasis is on performance, and nobody is allowed to be 'average,'" Neff explains. "Women in particular want to meet all the demands of the world—from being a good wife and having perfect children to having the perfect house. It seems like everyone must be special and

> ## The more we try to be perfect, the farther we drift away from who we really are.

exceptional." The way we're raised also plays a role, according to Neff. "If you frequently got the message—overtly or unconsciously—that you were not good enough, then the odds are that you got the critical inner voice from [people in your life]," she says. "And this can bother you all your life."

AS YOU ARE

American research professor Brené Brown also has an explanation for our collective lack of self-compassion. "Judging ourselves is a way to make us invulnerable to (potential) criticism," she writes. "We shield ourselves with toughness, severity, and critical self-judgments." In her book *The Gifts of Imperfection*, Brown explains that we want to do everything perfectly in order

to get recognition and to be included. By being self-critical, we hope to gain the approval of others. "But the problem is that the opposite happens, because the more we try to be perfect, the farther we drift away from who we really are, and this makes it harder, even when we experience approval," she writes. "We only feel included when we show who we really are and are accepted for it."

Self-compassion is about the relationship with our self, says Neff. This is a bit different from always seeking acknowledgment of our importance, which is more about how others judge us, or even how we judge ourselves.

WHAT IS COMPASSIONATE LIVING?

Mindfulness-Based Compassionate Living (MBCL) is what mindfulness courses build toward. It is particularly recommended to people who enjoy the benefits of mindfulness but still find it hard integrating it in their lives and developing a kinder attitude. You can read more in the book *Mindfulness-Based Compassionate Living* by Frits Koster and Erik van den Brink. Want to explore more mindful self-compassion? Read *Self-Compassion* by Kristin Neff and *The Mindful Path to Self-Compassion* by Christopher Germer or visit compassionateliving.info or mindfulselfcompassion.org. The Center for Mindful Self-Compassion has some online resources at centerformsc.org, too. Test how self-compassionate you are at self-compassion.org/test-how-self -compassionate-you-are/.

More compassion makes us worry less and makes us happier.

For this outward-oriented form of self-esteem, performance is necessary. "If you perform well, you feel good about yourself," says Neff, "but if you don't, you feel bad. Self-compassion means not feeling better than others, but not feeling worse either; it means being nice to yourself in hard times instead of judging yourself."

PRACTICE MAKES PERFECT

Practicing self-compassion can help us be kinder to ourselves. Mindfulness trainer Frits Koster, together with psychiatrist Erik van den Brink, developed an eight-week self-compassion course. "Self-compassion is the ability to involve ourselves and empathize with our inner difficulties," explains Koster. "This is a quality that's potentially there in all of us, but it hasn't always blossomed, and there can be all sorts of reasons." Fortunately, we are able to develop and deepen this quality. Practicing mindfulness is a good first step, according to Koster. His course is set up as a sequel to a beginner mindfulness course. While developing a warm and understanding attitude toward ourselves, difficult

emotions such as sadness can arise. If we are already familiar with mindfulness, then we have a framework to deal with them.

Neff agrees that mindfulness is an important part of self-compassion. You have to figure out why certain things are not working well before you can be compassionate toward yourself. "Often, our inner critic is so integrated into our thought processes that we can't see it," she says. "Mindfulness teaches you to recognize that voice, so you know who you are again."

One of the most important results of Neff's research is her finding that more compassion makes us worry less and makes us happier. "If you constantly feel like you are failing, you become jaded," says Neff. "You automatically keep focusing on negative information. But if you're kind to yourself and you remind yourself that everyone is connected, you can locate your warm and secure feelings. Then you stimulate the production of oxytocin (a feel-good hormone) in your body."

Our relationships are improved by a little gentleness.

NOT JUST FOR ME

Being kind to yourself has another effect: You become kinder toward other people. "When we are kind to ourselves, we create a reservoir of compassion that is there for

others," says Brené Brown. For your partner or your children, for example. "Our relationships are improved by a little gentleness." Koster agrees: "Self-compassion is indeed very helpful within relationships. For example, by not being too insulted by your partner's criticism, there's more room for an open discussion, so you can really see what's going on. Often this helps to make it even clearer how you can improve or change your relationship. Sometimes this means you need to take more space. Sometimes it means you need to give the other person more space. Either way, self-compassion helps because a kind and friendly approach toward yourself, and toward one another, opens up the communication."

Gea Kamphuis, mindfulness trainer: "I HAVE MORE CONTACT WITH OTHERS"

"I was curious and I wondered if I could be less hard on myself. I hoped the training could make me milder and give me more space to be who I really am. It was tough. I learned to see the things that I had been hiding away for years and that were painful for me. Now I am kinder to myself, less judgmental. I have learned ways in which I can be consciously milder toward others and toward myself. This has changed my perspective on life. I am more at ease and relaxed. I notice that I am not so shut off in my own world and this stimulates more contact with others. When I am busy, though, things get more difficult. I get caught up in things and become less aware of my own experiences. In these moments, it helps to do an exercise from the course. I imagine that I am in a safe place where I feel completely comfortable. This gives me a peaceful feeling and more self-acceptance."